LEGENDARY L

— OF —

GRAND RAPIDS
MICHIGAN

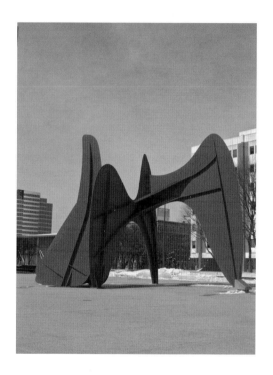

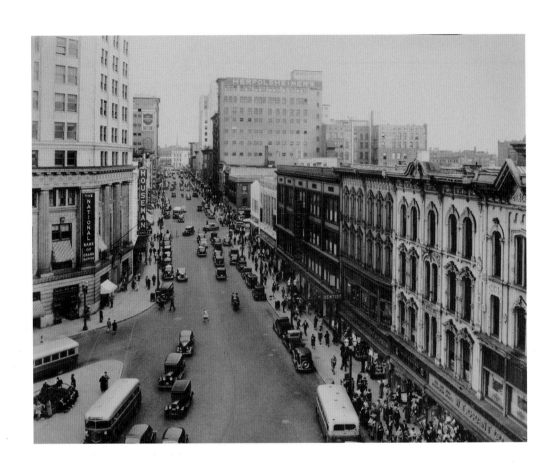

Page 1: Calder Stabile in Downtown Grand Rapids
The Calder was installed in 1969 and is looked upon by many as a symbol of the city. (Photograph by Norma Lewis.)

Page 2: Monroe Avenue
Monroe Avenue, once the city's retail center, c.1930s as seen from Campau Square.

LEGENDARY LOCALS
——— OF ———

GRAND RAPIDS
MICHIGAN

NORMA LEWIS AND JAY DE VRIES

Published by Legendary Locals, an imprint of Arcadia Publishing
Charleston, South Carolina

Printed in the United States of America

Library of Congress Control Number: 2012930629

For all general information, please contact Arcadia Publishing:
Telephone 843-853-2070
Fax 843-853-0044
E-mail sales@arcadiapublishing.com
For customer service and orders:
Toll-Free 1-888-313-2665

Visit us on the Internet at www.arcadiapublishing.com

Dedication

For David D. (Barb), Douglas, Michael (Lynda), Rhonda (Patrick), Daniel (Hazel), and David H.; and Nikole, Shyler (Julie), Jason, Jill (Thomas), Jonathan (Naoko), Ethan, Shelby, Shane, Iris, Lily, and Jasmine

On the Cover: From left to right:
(TOP ROW) Roger B. Chaffee, astronaut (Courtesy Public Museum, Grand Rapids; see page 97), Jacob Walker Cobmoosa, Native American activist (Courtesy Grand Rapids Public Library [GRPL]; see page 88), Connie Wisniewski and Ruth Lessing, Grand Rapids Chicks players (Courtesy GRPL; see page 75), Gerald R. Ford, 38th US president (Courtesy Gerald R. Ford Presidential Library; see page 103), Isaac Peter, Ottawa Indian (Courtesy GRPL; see page 89.
(MIDDLE ROW) Marion Ladewig, bowler (courtesy GRPL; see page 86), Chris Van Allsburg, illustrator and author (Courtesy Houghton Mifflin; see page 101), Arthur Vandenberg, US senator (Courtesy GRPL; see page 56); Hattie Beverly, educator (Courtesy GRPL; see page 30), Louis and Sophie Campau, early settlers (Courtesy GRPL; see page 12).
(BOTTOM ROW) Floyd Skinner, lawyer and activist (Courtesy GRPL; see page 79), Stan Ketchel, boxer (Courtesy GRPL; see page 43), Dr. Pearl Kendrik, codeveloper of whooping cough vaccine (Courtesy GRPL; see page 63), Mel Trotter, minister (Courtesy Mel Trotter Ministries; see page 44), children saying goodbye to their dog who was recruited for the Dogs for Defense program during World War II (Courtesy GRPL; see page 65).

CONTENTS

ACKNOWLEDGMENTS

Our heartfelt thanks to Tim Gleisner and the Local History department at the Grand Rapids Public Library, especially, M. Christine Byron for her suggestions and Karolee Gillman for expertly scanning many of the images that appear in these pages. We thank Alex Forist at the Public Museum, Grand Rapids. Thanks also to Richard Harms, John Cassleman III, Patrick Cook, Dr. Jennifer Petrovich, Rhonda Ayers, Scott McNeal, Jackie Middleton, Dick Ter Maat, Bob Becker, and Luis Ramirez. You took time to meet with us, and shared your memories and your images. It is a better book because of you.

We are grateful to Tiffany Frary and Erin Vosgien for their editorial excellence, and to all the unsung heroes at Arcadia Publishing who worked behind the scenes to make this book the best that it could be.

A great big thank you to all the unsung local heroes who do their thing day after day, and in so doing, make Grand Rapids a terrific place to live.

As always, we're grateful to our families for their unstinting support, help, and love.

Unless otherwise noted, all images appear courtesy of the Grand Rapids Public Library.

INTRODUCTION

Grand Rapids boasts an abundance of legends. The 38th president, Gerald R. Ford, grew up in the city, as did his wife, the former Elizabeth (Betty) Bloomer. Astronauts Roger B. Chaffee and Jack Lousma called Grand Rapids home. Heavyweights in the commerce and industry arena include Fred Meijer, Jay Van Andel, Rich DeVos, and Peter Cook. Giants during the glory days when Grand Rapids reigned as Furniture City included the Slighs, Widdicombs, Stickleys, Kindels, and Forslunds, to name a few.

In earlier days, downtown Grand Rapids was primarily retail establishments and the furniture factories that located along the Grand River for ease of transportation. That changed over the years as the railroads and trucking became more efficient ways of moving the finished products. The furniture factories became obsolete, and instead of rebuilding here, one by one they moved to North Carolina. Retail establishments abandoned the city in favor of suburban malls with adequate free parking. Shoppers preferred multiple shops under one roof in Michigan's often less than ideal weather.

Downtown Grand Rapids reinvented itself in the latter decades of the 20th century and is now a flourishing educational center, medical corridor, and dining and entertainment mecca. Colleges located in or near the downtown area are Grand Rapids Community College, Grand Valley State College, Ferris State College's Kendall School of Design, Ferris's School of Pharmacology, Western Michigan University and Thomas M. Cooley Law School. Davenport College, once on Fulton Street, has relocated its main campuses to the East Beltline in Grand Rapids and Holland but still maintains a downtown presence. The schools' expansions have been made possible through the generosity of the Meijer, DeVos, Van Andel, Cook, Wege, and other prominent local families.

Those same families have also made Grand Rapids nationally known for its medical excellence. Spectrum Health (formerly Butterworth and Blodgett Hospitals) and St Mary's (now called Mercy) Hospital provide the best of health care in the downtown area. Spectrum includes the Helen DeVos Children's Hospital and the Fred and Lena Meijer Heart Center. Mercy Hospital is home to the Wege Center for Mind, Body, and Spirit.

The Mary Free Bed Hospital and Rehabilitation Center had more humble beginnings and was initiated by average citizens unable to make large donations in 1891. They saw a need and pooled their resources to make it happen. They did this "in the name of all Marys."

The Meijer family made the local public broadcasting channel a reality. David Hunting's name is on the downtown YMCA. Sports and performance arts, along with fine dining and entertainment venues, bring people into the city and flourish under the sponsorship of the Meijers, Cooks, Van Andels, DeVoses, and all the others who made the city what it is today.

That includes its reemergence as a convention center. In the old days, furniture buyers filled the city during the twice-annual shows and related events. It has been a long time since we were a one-industry town. Today, downtown hotels host conventions covering a wide variety of interests. One of those hotels happened when Jay Van Andel and Rich DeVos took over the Pantlind Hotel and refurbished it while maintaining its original elegance. The old Pantlind, now the Amway Grand, has always been a top dining spot. As old favorite restaurants close, new ones take their place, the latest being the addition of Ruth's Chris Steak House on the hotel's first floor. Another downtown hotel is owned and operated by Bob Sullivan, a legend in local baseball lore.

A few of the writers from Grand Rapids are Newberry medalist Meindert De Jong and Newberry Honor-winner Gary Schmidt, along with Caldecott medalist, illustrator, and author, Chris Van Allsburg, of *Polar Express* fame. Among the many others are David Cornel De Jong, Constance Rourke, and Bich Nguyen, not to mention the prolific Stewart Edward and Betty White, who claimed the spirits dictated their works. Maybe there really is a writers' muse. Legendary Hollywood director and screenwriter Paul Schrader is Grand Rapids born, and a Calvin College graduate. His film, *Hardcore,* reflects that background. Actor Dick York lived here, and so did rock star Del Shannon.

Religion played a large role in the lives of many of the locals, and among the local colleges, five are religion-based: Calvin College and Seminary, Aquinas College, Kuiper College, Cornerstone University, and Grace Bible College. The Dutch, who were once the largest immigrant group in the area, opened Calvin Seminary in 1876 with one instructor, Geert Boer. Calvin College grew out of the seminary. The Dominican-run Aquinas first opened its doors in 1886 as the Novitiate Normal School.

Grand Rapids roots-roots-roots for the home team no matter what the sport. That often means the Detroit Tigers, especially back when local boy Dave Rozema pitched. The city sent Chris Kaman to the National Basketball Association's Los Angeles Clippers, and Matthew Steigenga to the Chicago Bulls. During the 1940s and 50s, the Grand Rapids Chicks played in the All American Girls Professional Baseball League and brought home two championships. Non-team sports legends include bowler Marion Ladewig and runner Greg Meyer.

But this city isn't all about famous residents and former residents. It's the unsung heroes of the past and present that contribute to an area's character. People like Dr. Jennifer Petrovich, a veterinarian who founded Crash's Landing and named it for Crash Purr-Do, a severely injured kitten she was able to mend. Miguel Navarro came to the area to pick celery and ended up founding the El Matador tortilla chip factory. The Army Air Corps didn't trust Virgil Westlake to fly their planes because his father was Japanese. Instead they placed him in the 442nd Regiment. He ended up in the unit that shot the locks off Dachau concentration camps.

Unsung heroes serve the country in wars. Some teach the city's children or take care of the infirm. Others put out fires and patrol the streets, making it a safer place. Grand Rapids is long on heroes and proud of them all.

CHAPTER ONE

The Early Years

The Hopewell Indians occupied the Grand River Valley from about the time of Christ until they disappeared sometime before the 1700s, leaving only their burial mounds as proof of their existence. The Odawas followed in the 1700s, and it is they who greeted the white missionaries and fur traders. The traders introduced the Indians to alcohol, thus making the work of the missionaries more difficult.

Then came the permanent settlers. Despite the challenges of establishing a new city on the banks of the Grand River, and all that entailed, the settlers were sometimes contentious. Louis Campau and Lucius Lyon engaged in a feud, the evidence of which can still be seen in the layout of the original city. Campau wanted to name the village Grand Rapids, and paved old Indian trails. Lyon's streets were orderly square blocks. He thought the name should be Village of Kent.

One of the earliest industries was plaster mining. Lucius Lyon operated salt wells. Some opened flourmills, sawmills, and foundries. Logging was big business in most of the state. As more settlers came, their increasing needs had to be met. That meant more merchants, teachers, and doctors. The first white wedding took place in Joel Guild's house, as well as the first town meeting. John Ball Park is a popular reminder of the contributions made by one of the city's earliest settlers.

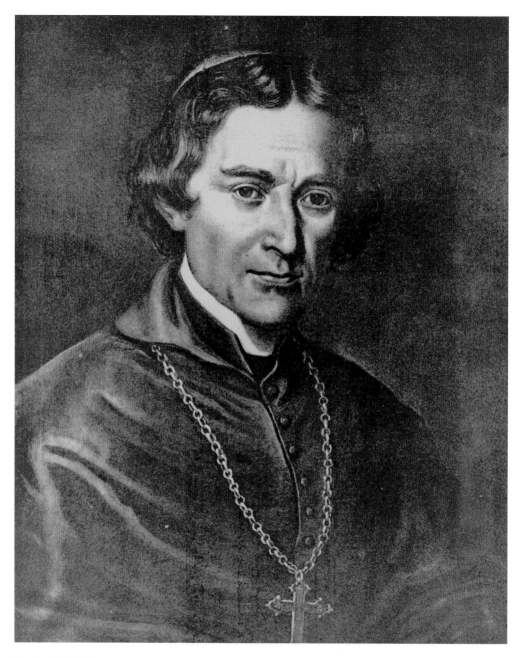

Fr. Frederic Baraga
Born in Slovenia in 1797, Baraga left behind a life of privilege and became a priest. He established the Mission of St. Mary on the Grand River in 1833 and stayed two years before heading to northern Michigan and the Upper Peninsula, where he was known as the Snowshoe Priest because he traveled on snowshoes to serve remote and far-flung missions. The Upper Peninsula honors him with Baraga County, and with a statue of him with snowshoes. He was replaced in Grand Rapids by Fr. Andreas Viszoczky. After leaving the area he was named a bishop, and his canonization process was begun in 1998.

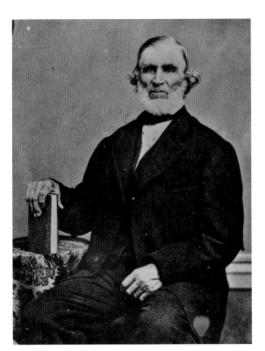

Rix Robinson

Robinson, born in Richmond, Massachusetts, became interested in the fur trade while traveling with American troops during the War of 1812. After becoming a limited partner in John Jacob Astor's Hudson Bay Company, he took over a trading post where the Grand and Thornapple Rivers join at what is now the village of Ada. Recognized as Kent County's first permanent white settler, he remained active in state politics including serving as state senator. He founded Grand Haven, Michigan, in 1835, and four of his brothers, Rodney, Edward, John, and Ira, settled Robinson Township. On June 30, 1887, the Old Residents Association of the Grand River Valley dedicated the monument they erected to honor Robinson as seen in image below.

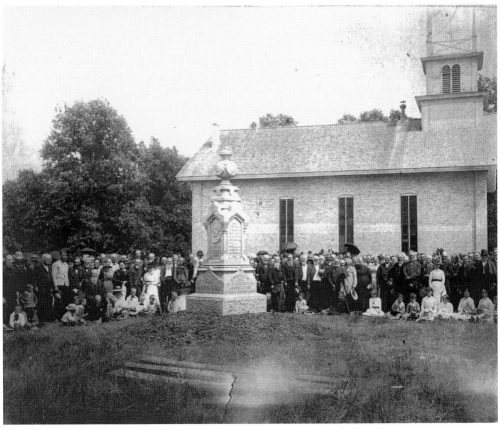

Louis and Sophie Campau
Among the first settlers was Louis Campau, who established a trading operation in 1826. He recognized the potential of the area and became a land speculator, later selling his property to new settlers. Campau also started a bank. In gratitude for his successes, he financed the building of a Catholic church in 1837, but his contentious relationship with Fr. Andreas Viszoczky ultimately led to the entire membership (except Louis and Sophie) abandoning the church in favor of an Indian chapel. His gratitude was a bit premature as the bank ultimately failed, and it is said that he then papered some of the walls in his home with the worthless banknotes.

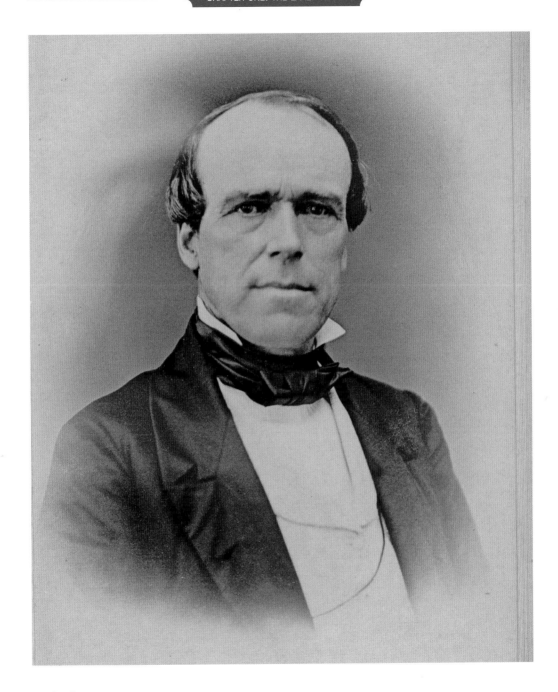

Lucius Lyon
Fr. Andreas Viszoczky wasn't the only one with whom Campau quarreled. He also had a longstanding feud with Lucius Lyon, another early settler, and a surveyor. Lyon holds the distinction of becoming the city's first congressman in 1843, but had served as Michigan's first US senator from 1837 to 1839, prior to his move to Grand Rapids. Though elected in 1835, he was first called a spectator senator. It was not until Michigan was admitted to the Union in 1837 that he received full Senate status. His election to Congress made him the first Michigander to serve in both houses.

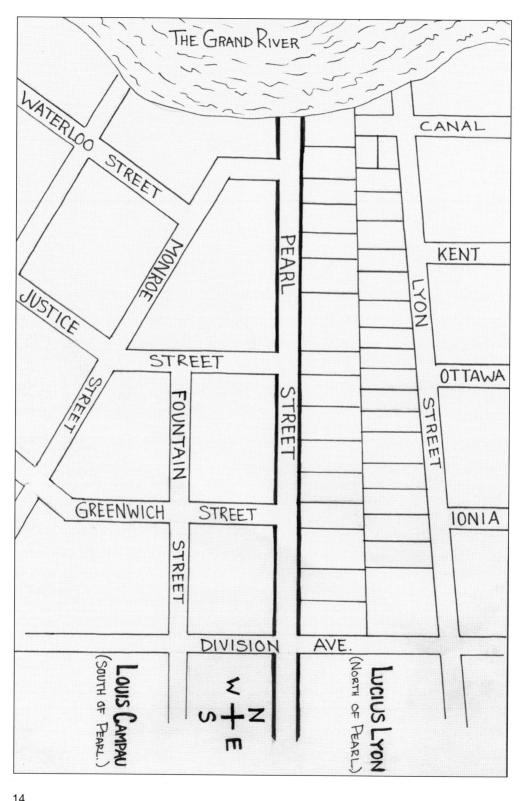

Map (LEFT)

This map illustrates the result of the Campau and Lyon feud over the laying out of the city. Lucius Lyon's neatly planned squares are a sharp contrast to the diagonal paths of Louis Campau. (Courtesy of Jillian Berry.)

Joel Guild

Guild arrived in 1833, and for $25, bought land from Louis Campau. He built the city's first frame house on what is now the site of the McKay Tower on Monroe Center. Guild hosted the first town meeting on April 4, 1834, with nine attendees. His house was also the venue for the marriage of his daughter Harriet to Barney Burton, the first white couple married in the new town.

Harriet Guild

Harriet was the first of Guild's seven children. Her brother, Consider Guild, was two years younger, and was followed by five more girls. Following their marriage on April 13, 1834, the couple lived on Burton's farm. Known in her later years as Aunt Hattie, Harriet became one of the most beloved women in town, and is shown here at her spinning wheel.

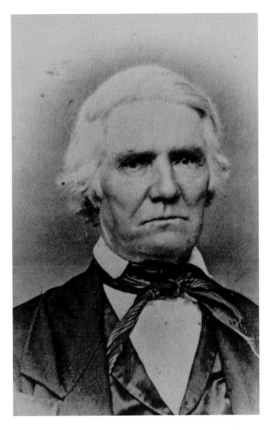

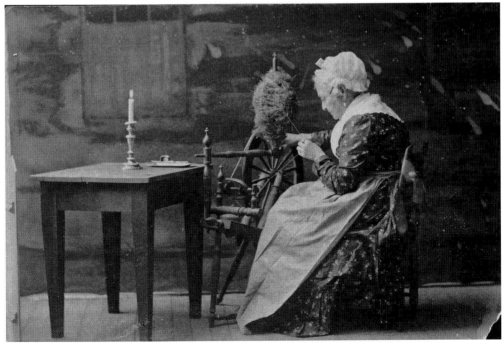

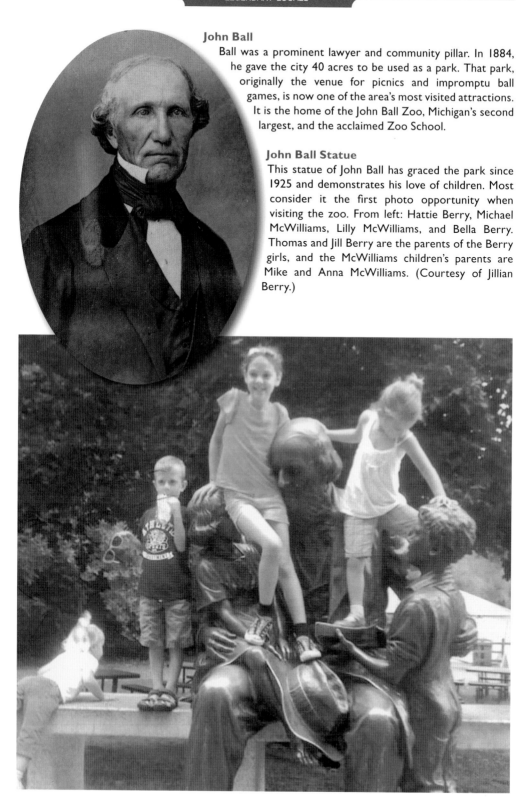

John Ball

Ball was a prominent lawyer and community pillar. In 1884, he gave the city 40 acres to be used as a park. That park, originally the venue for picnics and impromptu ball games, is now one of the area's most visited attractions. It is the home of the John Ball Zoo, Michigan's second largest, and the acclaimed Zoo School.

John Ball Statue

This statue of John Ball has graced the park since 1925 and demonstrates his love of children. Most consider it the first photo opportunity when visiting the zoo. From left: Hattie Berry, Michael McWilliams, Lilly McWilliams, and Bella Berry. Thomas and Jill Berry are the parents of the Berry girls, and the McWilliams children's parents are Mike and Anna McWilliams. (Courtesy of Jillian Berry.)

CHAPTER TWO

1851–1900

The name Grand Rapids prevailed over Village of Kent, and the city incorporated in 1850. The following years brought enormous growth in commerce, industry, education, and services. The Civil War produced heroes including Russell Alger, Charles Belknap, and Joseph Herkner.

When residents celebrated the 1876 Centennial, they celebrated more than the nation's freedom. It was the city's 50th birthday, and the burgeoning furniture industry had put Grand Rapids on the map when local furniture manufacturers took top honors at the Philadelphia Centennial Exposition. This caused additional growth, as more factories opened, and furniture support industries flourished. More hotels were needed to accommodate the throngs of buyers attending the twice-annual furniture market. Hotelier Boyd Pantlind rose to the challenge. William P. Drueke had a thriving liquor business, though Prohibition would force him to close its doors. The family rebounded with the Drueke Game Company. Also, on the industrial front, Anna Bissell took over the Bissell Company following the death of her husband, Melvin.

In 1888, Rev. Geert Boer became the first president of Calvin Seminary. Julius Houseman, with his cousin, Joseph Houseman, helped establish the city's first synagogue. Hattie Beverly became the first black school teacher, and a few men interested in science formed the Grand Rapids Scientific Club, an organization that laid the framework for the present-day Public Museum. Also in 1888, members of the Eastern Avenue Christian Reformed Church staged the Dummy Line Riot, effectively stopping a streetcar line from disrupting their Sabbath services.

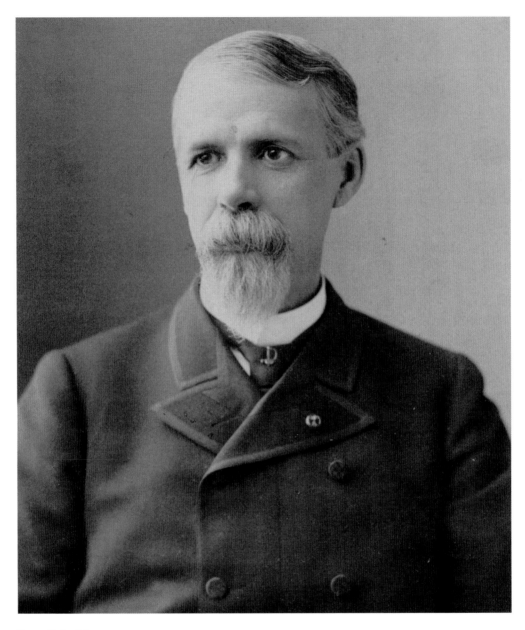

Russell A. Alger
Alger moved from Ohio to Grand Rapids in 1859 and opened a law office. During the Civil War, he enlisted in the Union Army as a private, and worked his way up to major general, but was wounded and forced to resign. Soon after, he married Annette Henry. Alger is remembered as a lumber baron, and though he eventually moved to Detroit, the mark he made on Grand Rapids is evident. Both a neighborhood and a street bear his name. A Republican, he was elected governor of Michigan in 1884. His only failure came when Pres. William McKinley named him secretary of war in 1897 and his performance made the term Algerism a synonym for bureaucratic incompetence. He was appointed US senator in 1902 to finish the term of James McMillan, who had died in office. Alger also died in office in 1907.

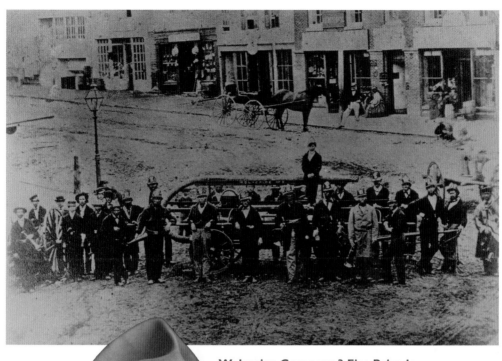

Wolverine Company 3 Fire Brigade

Firefighters are by definition heroes, and never more so than in the days when they were all volunteers and lacked today's sophisticated equipment. Not only were they unpaid, the early firemen were fined 50 cents if they missed a fire. Pictured here in 1860 is the Wolverine Company 3 Fire Brigade. Charles Belknap is holding a trumpet at the far left. The gaslights were installed in 1857.

Charles Belknap

In 1862, at age 15, Charles Belknap joined the 21st Michigan Infantry as a private. Within two years he made captain. Wounded seven times at Chickamauga, Belknap was also part of Sherman's March to the Sea. After farming for six years, he founded the Belknap Wagon and Sleigh Company. Active in the community, he was a volunteer fireman, then assistant chief. He held various local offices before his election to Congress in 1889.

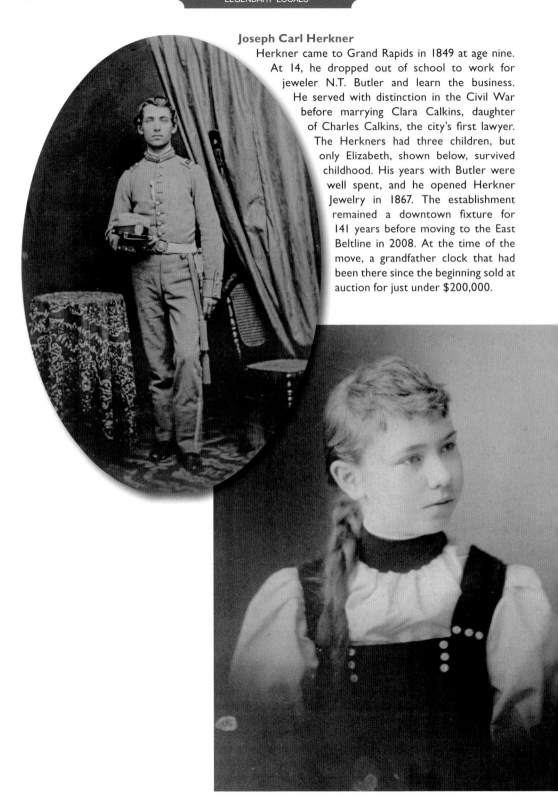

Joseph Carl Herkner

Herkner came to Grand Rapids in 1849 at age nine. At 14, he dropped out of school to work for jeweler N.T. Butler and learn the business. He served with distinction in the Civil War before marrying Clara Calkins, daughter of Charles Calkins, the city's first lawyer. The Herkners had three children, but only Elizabeth, shown below, survived childhood. His years with Butler were well spent, and he opened Herkner Jewelry in 1867. The establishment remained a downtown fixture for 141 years before moving to the East Beltline in 2008. At the time of the move, a grandfather clock that had been there since the beginning sold at auction for just under $200,000.

Albert Stickley

The name Stickley has long been associated with fine furniture, especially in the Arts and Crafts style. Albert and his brother John George opened their factory in 1881, during the days when Grand Rapids dominated the industry. As furniture makers, they joined the ranks of the Widdicombs, Slighs, Kindels, Hekmans, Johnson Brothers, and numerous others. John George eventually went back to the East Coast and opened a factory there with another brother, leaving Albert to run the operation alone until his 1927 retirement. The factory closed in 1947, in order to consolidate all the Stickley furniture enterprises in New York State.

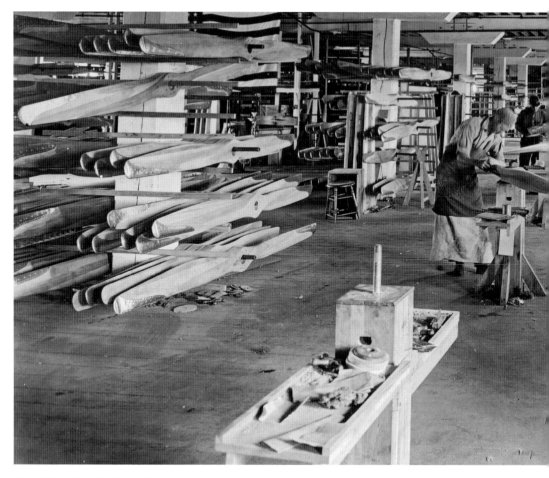

Grand Rapids Airplane Company

World War I required the assistance of the local factories. When the US Army needed 1,000 Handley-Page bombers for the war effort, 15 furniture companies rose to the challenge. Along with Stickley, Berkey and Gay, Century, Grand Rapids Chair, Grand Rapids Furniture, Grand Rapids Showcase, Imperial, Johnson, Macey, Phoenix, Royal, Sligh, Widdicomb, and Wilmarth formed a consortium they named the Grand Rapids Airplane Company. Each company dedicated a portion of its factory space to the project. They met the demand. Everything but the motors was Grand Rapids–made. Stickley was one of the factories making propellers.

James Seino (RIGHT)

Born in Japan in 1885, Seino came to Grand Rapids in 1914. A talented artist, he had graduated from Japan's Imperial Academy of Art, and studied further in both New York and Paris. With that background he had no trouble finding work in the furniture industry, and by the early 1920s, was in charge of furniture decoration at the Stickley Brothers Company. He is shown here with one of his popular Asian-inspired designs. He, his wife Kaoru, and their sons, James Jr. and Robert, were the city's first Japanese family. (Courtesy of Public Museum, Grand Rapids.)

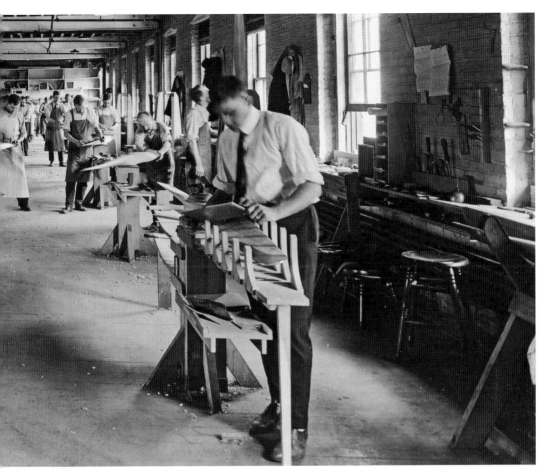

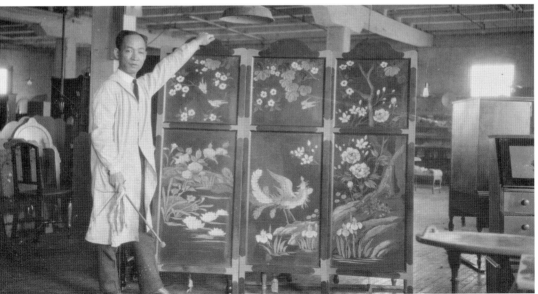

The Children of William F. and Rose Drueke with Rose From left, Joseph W., Rosemary sitting on her mother Rose's lap, Jane standing (front), Irene standing (rear), Will Jr., sitting, and Marian standing in rear.

Grand River Raft Race

Companies, groups, and individuals participated in the annual raft race on the Grand River. The race, sponsored by WLAV Radio, was very popular from the 1970s through the mid 1980s. While some rafts were constructed for show and included everything from floating Fred Flintstone car look-alikes to outhouses, the Drueke 1976 craft looks as if it was built for speed. All were made for a fun summer day on the river.

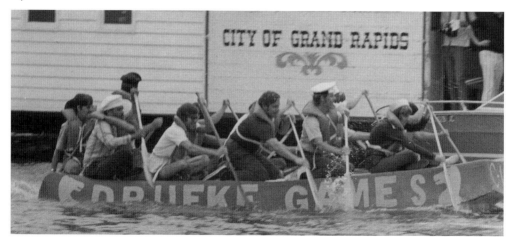

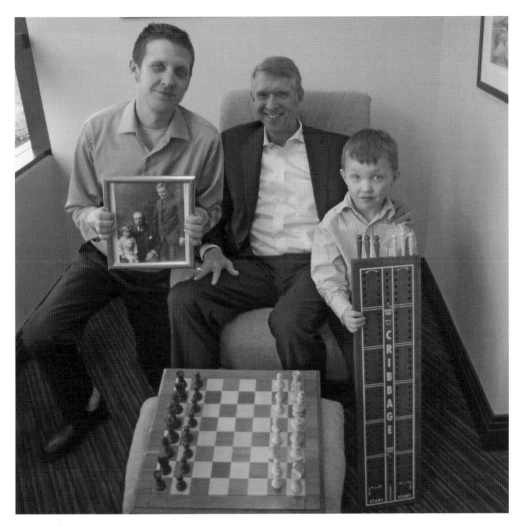

Drueke Family

In 1873, German-born William Peter Drueke, at age 20, came to Grand Rapids, probably with his sister, Anna Sophie, and her husband. That brother-in-law, Frederick Wurzburg, opened the Wurzburg Department Store in 1913. William's marriage to Elizabeth Berles in 1882 took place at St. Mary's Catholic Church, where various relatives were founding members. He went into the wholesale liquor business with Alexander Kennedy, but became sole owner in 1888. Michigan voted for Prohibition in 1916, two years ahead of the rest of the country, thus ending the business. In 1914, one of William's eight children, William Francis, established William F. Drueke and Sons, to produce high-quality chess sets and cribbage boards, relying on a ready labor pool of skilled carvers drawn to the area by the furniture industry. For 82 years the company flourished, turning out an ever-expanding variety of games to appeal to changing markets. Paul Drueke, a Grand Rapids financial advisor/senior vice president with Stifel Nicolaus and Company, remembers traveling with his father and demonstrating the product line. After three generations, the family sold the business to the Carrom Company in 1992. The games, still American-made, are now produced in Ludington, Michigan. Those that originated with the Drueke company still carry the family name. Shown here are six generations of Druekes. Seated from left are Nate, Paul, and Isaac. In the framed photograph held by Nate are William Francis Jr., William Peter, and William Francis. Paul is the son of William Francis Jr. (Both images courtesy of the Drueke family.)

25

Geert E. Boer

Reverend Boer, his wife Jetsche, and their eight children were one of many Dutch families finding their way to Grand Rapids in 1873. Unlike most, Boer wasn't searching for new opportunities, as he had been called to serve the Spring Street Christian Reformed Church. The denomination was establishing a seminary, and in 1876, Boer became its first teacher. He had seven students and classes were held on the second floor of a school building on Commerce Avenue and Williams Street. It was a six-year curriculum consisting of four years of literature and languages followed by two years of theology. He taught all the subjects, and the library contained some of his own books. Ten years later Boer was installed as the first president of Calvin Seminary. He died in 1904 at age 72. (Courtesy of Heritage Hall, Calvin College.)

Emma Cole
Cole began teaching at Central High School in 1881. At that time, Central was also the site of the Kent Scientific Institute, which evolved into the Public Museum of Grand Rapids. It was a good fit, as she loved nature and had studied botany, zoology, math, and physics at Cornell University. She became one of the first female members and chaired the institute's botany committee, where she was given the responsibility of creating a herbarium. That herbarium was the cornerstone of the museum's natural history collection and is today on permanent loan to the University of Michigan. Cole worked with, and shared her research with, other botanists of the day. She died in Mexico in 1910 while picking flower specimens.

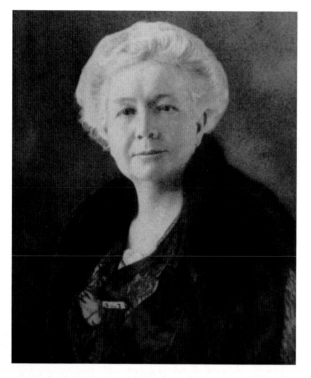

Anna Bissell

Melville Bissell first operated the store shown here. He invented his carpet sweeper in 1870 because his wife, Anna, had difficulty keeping her rugs clean. By the 1890s, the Bissell company was producing 1,000 sweepers a day. That would be the end of the story if Bissell hadn't died in 1889, leaving Anna to run what became an empire. Women didn't manage corporations; they couldn't even vote. Anna Sutherland Bissell ran the business with a firm hand, and her standards still define the company. Anna felt she was more sensitive to her employees' needs than a profit-driven man might have been, and she earned the respect of her male workforce. Under her direction, Bissell became what many believe was the country's first corporation with employee benefits and retirement plans. When Mark Bissell became CEO in 1994, he was the fourth-generation family member to head what is now called Bissell Homecare.

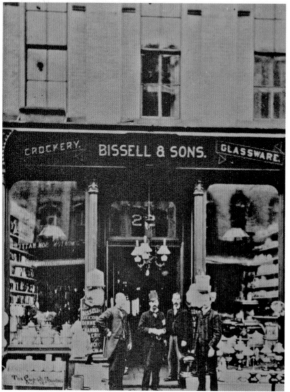

J. Boyd Pantlind (RIGHT)

Hotelier A.V. Pantlind came to the city in 1874 to manage the Morton House. After his 1896 death, his nephew J. Boyd Pantlind took over the Pantlind enterprises. In 1902, he bought Sweet's Hotel and renamed it the Pantlind Hotel. This preceded the days of trash collection, so Pantlind fed the hotel's garbage to his pigs. The city also owned pigs and sued Pantlind for the hotel garbage. The city won. Richard DeVos and Jay Van Andel purchased the hotel in 1978, restored it, and changed the name to Amway Grand Plaza. It remains one of, if not the, finest in the city. A streetcar bore Pantlind's name until 1855.

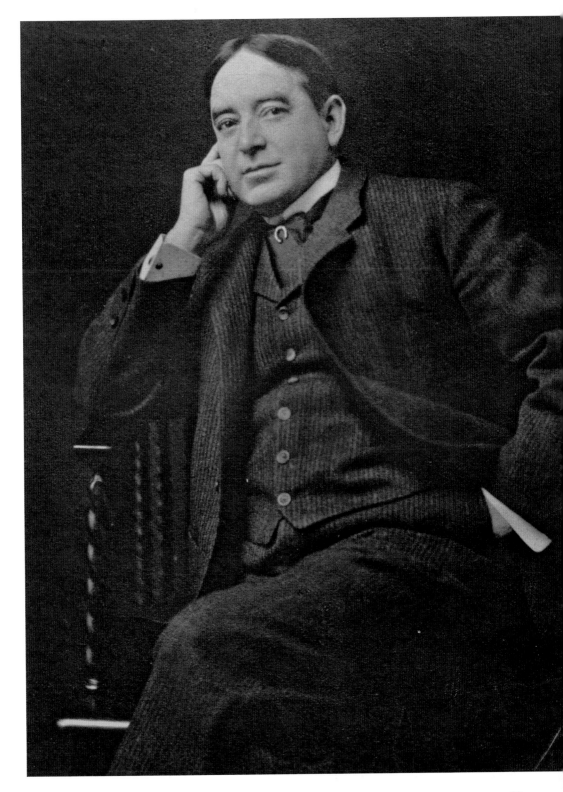

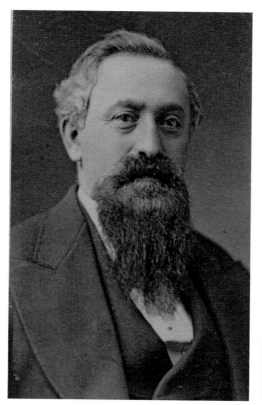

Julius Houseman (ABOVE)

The growing city lacked a synagogue, a situation that was remedied by cousins Julius and Joseph Houseman. In September of 1897, Jacob Levy, a fur trader, died in the area and Grand Rapids had no orthodox Jewish burial site. The Housemans led a movement to raise money for a site on Union Avenue. This led to the founding of the Jewish Benevolent and Burial Society. Out of that effort came Temple Emanuel, Michigan's first Jewish house of worship outside of Detroit. The congregation outgrew the building shown above and moved to 1715 E. Fulton in 1952. (Photograph by Norma Lewis.)

Hattie Beverly

In 1897 Beverly, an exemplary student in the Grand Rapids Public Schools teacher-training program, completed her assignments and substituted for absent teachers. But upon graduation, she almost wasn't hired. Because Hattie was a Negro, some thought she shouldn't have authority over white children. Common sense prevailed. Accepting her as a student implied future employment, and she became the city's first black teacher. Established in her memory are the Hattie Beverly Tutoring Center, and annual Hattie Beverly Award given by Grand Rapids Community College to a local black educator.

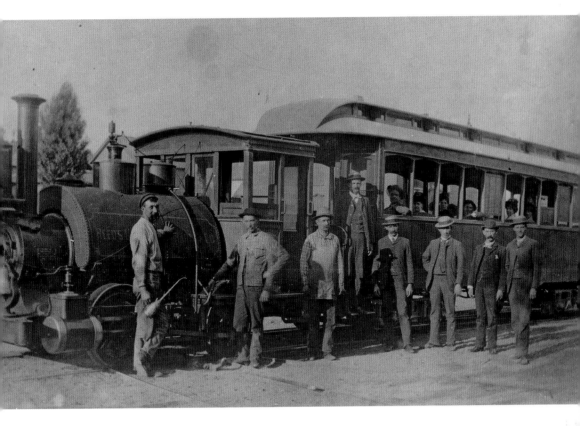

The Dummy Line Riot of 1888

Members of the Eastern Avenue Christian Reformed Church objected when a proposed Street Railroad Company expansion meant that a steam engine pulling a train of a dozen or more streetcars would run close to their building seven days a week. What they considered a symbol of encroaching secularism would endanger their children, rattle their windows, and disrupt their Sunday services. Worse, it would transport sinners to Ramona Park for revelry, dancing, and gambling, all verboten. They tried a peaceful solution first, and filed a petition. But the court found in favor of the railroad and work began. Summoned by ringing church bells, members gathered at the work site and tore up track. As workers attempted to spike a rail at one end, 20 protesters tore up the other end and threw the pieces in the frog pond. After police dispersed the crowd, the rail employees thought the donnybrook was over and worked all night to finish laying the track.

The opposition was down but not out, and the next day the bells pealed again. This time about 1,000 people responded. They removed the track and threw stones at anyone who tried stopping them. Some injuries occurred. Again the police came, but as fast as they placed the protesters in the paddy wagon, their friends broke them out. The church members, all Dutch, were doing what they thought right. After all, the Bible teaches the faithful to remember the Sabbath and keep it holy. Holy did not mean dancing, and it especially didn't mean dancing at Ramona Park. Though many considered the popular Reed's Lake amusement park a place to unwind on weekends, the Calvinist Dutch saw it as the devil's playground.

The church history says that though the vigilantes broke the law, they were pious people, and simply wanted to protect their right to worship in peace. First a temporary, then a permanent injunction stopped the railroad. The dummy line won the first battle, but the God-fearing people of the Eastern Avenue Christian Reformed Church won the war. The names of the streetcar rail workers shown above are unknown.

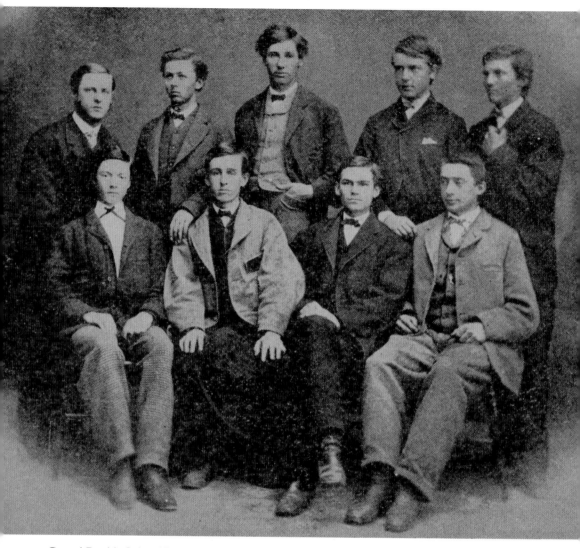

Grand Rapids Scientific Club
Grand Rapids Scientific Club members shared a passion for preserving scientific artifacts. They amassed a collection that became the Kent Scientific Museum, forerunner of the acclaimed Public Museum. From left are (front row) William H. McKee, George Wickwire Smith, Charles W. Garfield, and Hertel S. Finch; (back row) Henry J. Carr, Lorenzo G. Winchester, Eugene Sawyer, Theodore Wilson, and Frank W. Ball. (Courtesy of the Public Museum, Grand Rapids.)

Delos A. Blodgett Jr.

Blodgett was born in Otsego County, New York, March 3, 1825. He became a lumber baron, investing in forest land before settling in Grand Rapids in 1881. Upon arrival, he became involved in banking and finance and was a stockholder or management (sometimes both) of the Fourth National Bank, the Kent County Savings Bank, and the Grand Rapids Fire Insurance Company, among other financial institutions. In 1850, he married Jane Wood, of Woodstock, Illinois. Blodgett was known for his philanthropy, but Jane was the driving force in what arguably became his greatest legacy, the D.A. Blodgett Home for Children, now called D.A. Blodgett St. John's. Jane, with Emily Clark, was planning a program to ease the adoption of orphans. D.A. provided money to make it happen. Blodgett died in 1908. The portrait below shows D.A. with his mother and sister Helen, is from the 1880s.

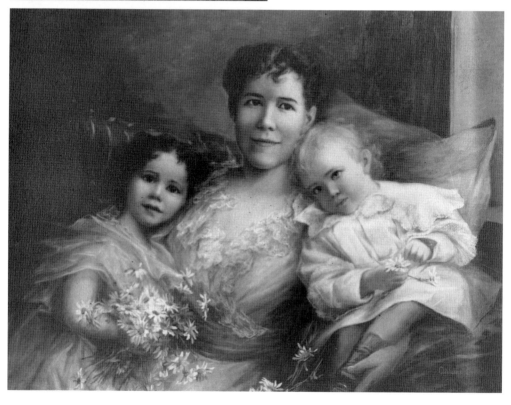

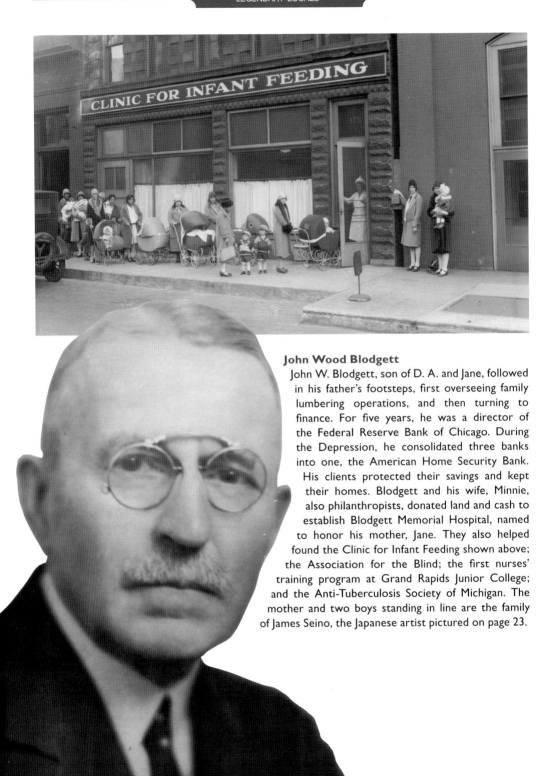

John Wood Blodgett

John W. Blodgett, son of D. A. and Jane, followed in his father's footsteps, first overseeing family lumbering operations, and then turning to finance. For five years, he was a director of the Federal Reserve Bank of Chicago. During the Depression, he consolidated three banks into one, the American Home Security Bank. His clients protected their savings and kept their homes. Blodgett and his wife, Minnie, also philanthropists, donated land and cash to establish Blodgett Memorial Hospital, named to honor his mother, Jane. They also helped found the Clinic for Infant Feeding shown above; the Association for the Blind; the first nurses' training program at Grand Rapids Junior College; and the Anti-Tuberculosis Society of Michigan. The mother and two boys standing in line are the family of James Seino, the Japanese artist pictured on page 23.

Emily Burton Ketcham

Ketcham was determined to vote. An organizer of the local National Woman Suffrage Association, she also served as president of the state organization. She made a rousing speech in the Woman's Building of the Chicago World's Fair of 1893, and was able to bring the 1899 annual convention to Grand Rapids. The five-day event opened April 27, 1899. In celebration of the convention's centennial, Mayor John Logie declared April 27, 1999, Emily Burton Ketcham Day. She died in 1907 before seeing nationwide suffrage, but the lower image shows her work being carried on in 1912 by, from left, unidentified, Mrs. Lois Jones, Mrs. Fred Rowe, Mrs. C.B. Hamilton, Mrs. W.F. Blake, and Mrs. Huntley Russell.

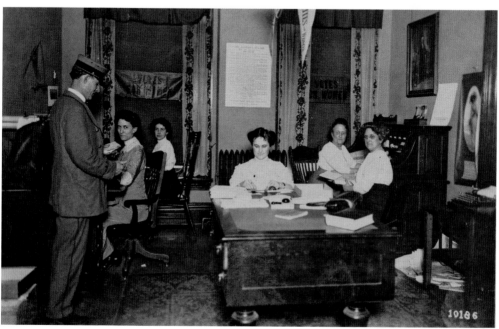

Nora Carr

Carr divorced in 1885, something most women with five children would not have dared to even think of doing at that time. To support her large family, she sold perfume and soap door-to-door. She might have been considered an early-day version of Avon Calling, except Nora not only marketed the products, she manufactured them in her kitchen. A second marriage followed, but left her widowed within a few years. The death of her second husband prompted her to expand the business she called Forever Young, and she soon had nearly 70 employees. After her death in 1915, her children ran the business for another 35 years before selling to the Consolidated Chemical Company in Chicago. (Courtesy of Marietta Kohl.)

Josephina Ahnefeldt Goss

Goss was a trailblazer in Grand Rapids education. In a career that spanned decades, she taught, served as principal, and was elected to the Board of Education where she served 10 years. Goss was head of the groundbreaking committee that introduced both kindergarten and a manual arts training program into the existing curriculum. Though education was her passion, she had other interests as well. She was an ardent suffragist, and she served a term as president of the Ladies Literary Society. In 1921, she was elected to the post of Grand Rapids Library commissioner.

Cadette Everett Fitch (LEFT)

Fitch was the daughter of Professor Franklin Everett, who came to the growing village in 1846 and assumed the position of principal at the Grand Rapids Academy. Cadette also taught, but only until her marriage to George Clay Fitch, a carriage maker, with whom she had two children. A passionate armchair traveler, she decided a real-life adventure was in order, and took her teenaged son, George, and daughter, Martha, on a rowboat trip down the Grand River. The three traveled at their leisure and spent nights in inns along the way. She is pictured here at about the same time as the river trip.

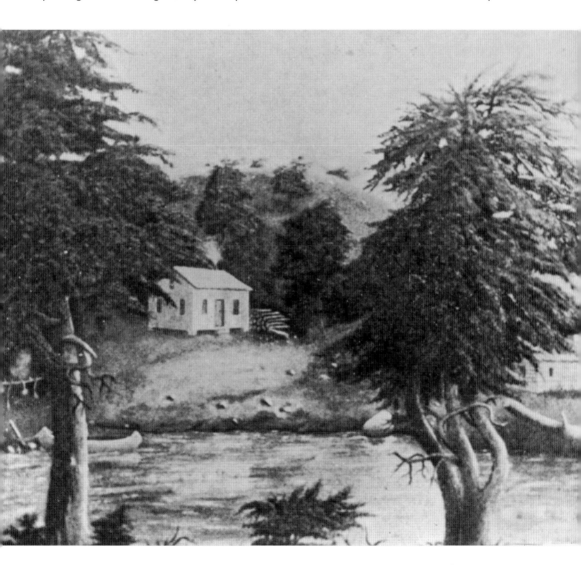

Drawing by Cadette Everett Fitch

Fitch kept a detailed journal, *A Few Idle Days*, of the trip. She enjoyed drawing and was considered talented. In the days before easy-to-use cameras, she sketched the scenery she rowed past. The seven-day adventure proved to be all the trio hoped it would be as is evidenced by a journal entry reading: We expressed much regret the river was only 40 miles long from our starting point. *This is one of her drawings from the trip, and is believed to be the cabin used by Joel Guild during the construction of his fine frame house.*

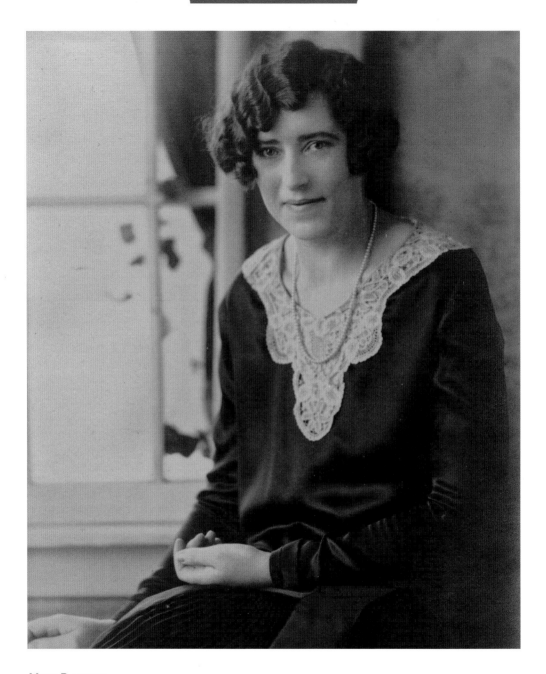

Mary Bennett

Mary and Jacob Bennett looked forward to the birth of their first child in June of 1913. When on the morning of June 4th, Mary realized the birth was imminent, she sent Jacob to summon the doctor. Infant John Bennett decided not to wait. Though still in excruciating pain, Mary managed to hold the infant on her abdomen and swaddle him with her blanket. Meanwhile, Jacob had been unable to find the doctor and came home with a police officer instead. Both were on hand to help when the reason for Mary's pain became evident. John's twin brother, Aaron, a complete surprise in those days before ultrasounds, joined the family a few minutes later. (Courtesy of Janet Kelley-Atkinson.)

CHAPTER THREE

1901–1950

These decades sorely tested Grand Rapids and the country at large. First World War I happened, then the Great Depression, World War II, and the Korean Conflict. The light at the end of tunnel came in the form of the postwar boom, and probably not coincidentally, the baby boom, both of which fueled the economy.

John Cassleman brought General Motors to the area with the stamping plant that opened in 1936, bringing much needed growth and prosperity to an area long deprived. When the construction workers needed warm outdoor clothing, merchant Earl Robson gave them everything they needed. They paid him back, and remembered his generosity by patronizing his department store for decades.

Mel Trotter managed a mission that soon bore his name, Wally Pipp hit record numbers of home runs, and Drs. Eldering and Kendrick developed the first successful whooping cough vaccine.

World War II made heroes of many local residents, and not just in the battle arenas. With a mixture of pride and tears, some area children sent their dogs to be trained for the Dogs for Defense program. Everyone contributed. Women went to the factories to produce war goods. South High School contributed in a huge way when the students raised enough money to buy a bomber.

On the lighter side, a German shepherd named Spooky served beers in a West Side bar, and the Grand Rapids Chicks baseball team enjoyed an enthusiastic following.

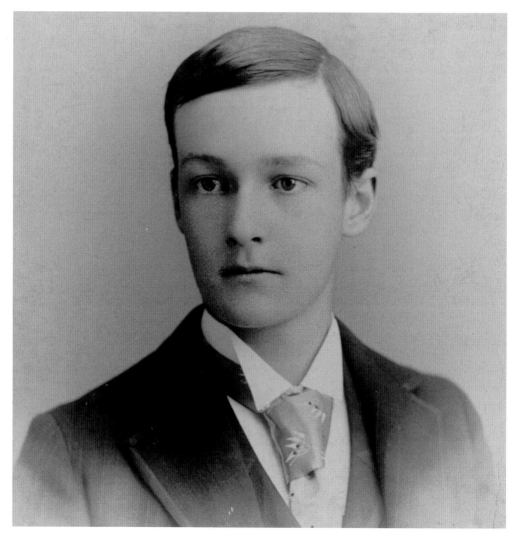

Stewart Edward White
Born in Grand Rapids in 1873, White was but one of the city's literary lights. At the turn of the 20th century, he wrote both fiction and nonfiction that focused on the country's growing fascination with the American West. White also traveled to Africa and other far-flung locales and wrote about his adventures. His writing took an eccentric turn in 1918 when he and his wife Betty discovered a Ouija board. They soon began publishing works they said were dictated to them from spirits. In 1940, White took that one step farther when he wrote *The Unobstructed Universe*, claiming it came to him from Betty, who had died the year before.

Stan Ketchel (RIGHT)
Long before Floyd Mayweather (another Grand Rapids native) Danced with the Stars, boxing legend Stan Ketchel became World Middleweight Champion. He held the title from 1908 through 1910. Known as the Michigan Assassin, Ketchel is still considered one of the greatest fighters of all time. Ketchel, born Stanislaus Kiecel on a farm near Grand Rapids, was a street scrapper with no training. What he lacked in finesse, he made up for in heart. His career ended abruptly on October 5, 1910, when he was shot and killed by Walter Dipley, the boyfriend of Ketchel's housekeeper and companion, Goldie Smith.

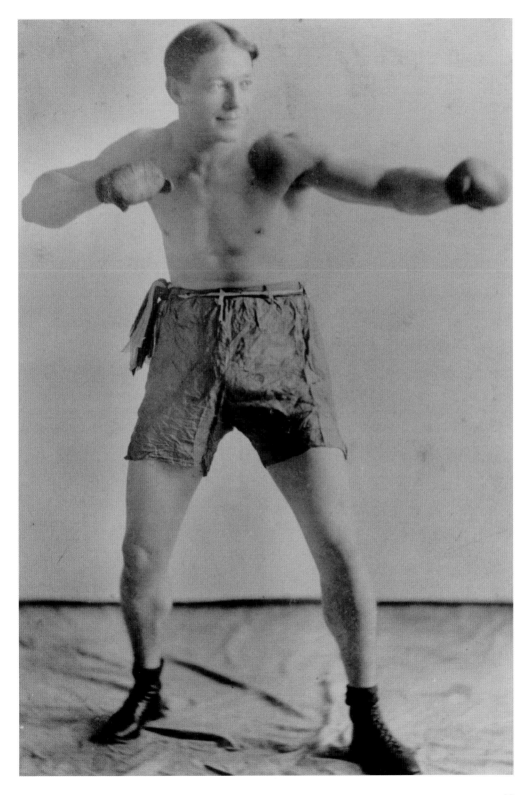

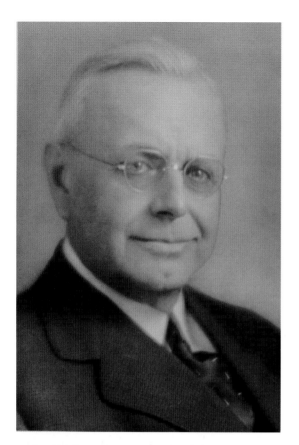

Mel Trotter

In 1897, Trotter felt his life was over. An alcoholic and gambler, he had gone home after a binge and learned his two-year-old son had died. He left his wife, Lottie, and ended up on skid row in Chicago. Instead of committing suicide as planned, he visited the Pacific Garden Rescue Mission, a decision that changed his life. He reconciled with Lottie and became a minister. Hired to manage the Grand Rapids City Mission, shown below when it was housed in the old Smith's Opera House, Trotter ministered to the same kind of men he had once been. That mission, now Mel Trotter Ministries, is still going strong, teaching God's love, offering hope to the homeless, and operating thrift shops. Trotter, with his brothers George and Will, helped create 67 similar missions across the country. (Courtesy of Mel Trotter Ministries.)

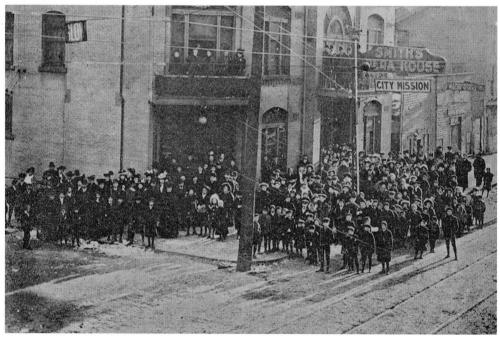

Constance Rourke

Born November 14, 1885, Rourke graduated from, and also taught at, Vassar College, prior to relocating to Grand Rapids. The author is remembered as a chronicler of the American culture of her time, and wrote books about Davy Crockett and James Audubon among others. Some of her other works reflected her interest in the seeds of American humor, Native Americans, the everyday affairs of ordinary people, and how people were shaped by the culture of their environment. She started what was to have been an epic work on humor. The work went unfinished when Rourke died in Grand Rapids in 1941 at age 56, following a fall on her ice-covered porch.

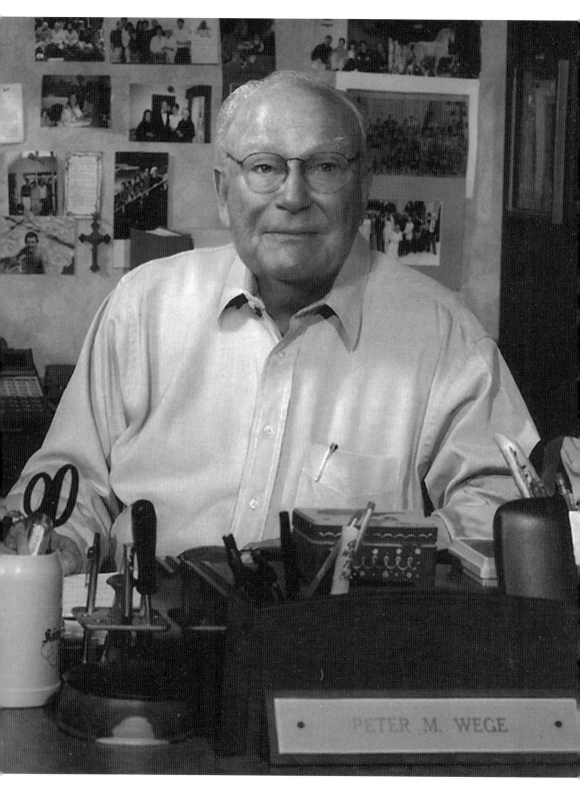

PETER M. WEGE

Peter Melvin Wege (LEFT)
Wege's father, Peter Martin Wege, was a co-founder of Steelcase. Peter Melvin Wege has followed in his footsteps, and is a heavyweight in the local business and philanthropy arenas. The former CEO of Steelcase is known for his generosity. An example is the Wege Center at Aquinas College, where he has been actively involved to the extent of taking a leave of absence from Steelcase to oversee the construction of Wege Center. To use his wealth to best advantage, he founded the Wege Foundation in 1967. The foundation's mission is supporting endeavors to create an environment in which all life can flourish through Education, Health, the Arts, and Economicology, the latter a word coined by Wege to strike a balance between economy and ecology. (Courtesy of the Wege Foundation.)

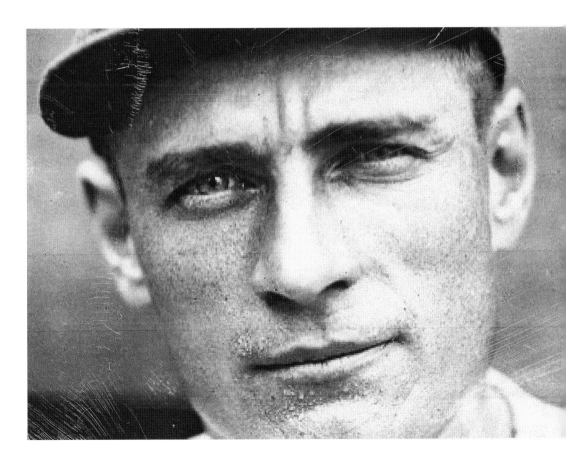

Walter Clement (Wally) Pipp
Pipp was born in Chicago in 1893, but grew up in Grand Rapids. Though he began his professional baseball career with the Kalamazoo Celery Champs in 1912, the Detroit Tigers took him on before the end of his first season. Pipp ultimately became one of the top hitters of the Deadball Era. He went on to play for the Yankees and the Cincinnati Reds before retiring in 1928. He was remembered for the famous headache he suffered while playing for the Yankees on June 2, 1925. There was nothing remarkable about the headache itself, but when he was unable to play, a rookie named Lou Gehrig took his place for the day, and then took his position on the team. Pipp ended his career with the Cincinnati Reds. He died in a Grand Rapids nursing home following a series of strokes in 1965.

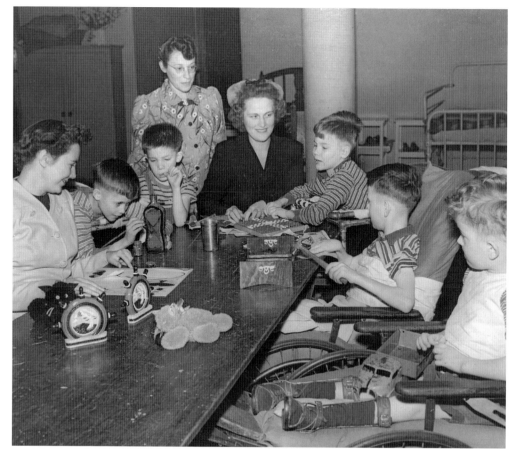

The Marys Behind the Mary Free Bed Hospital and Rehabilitation Center

In 1891, there was a growing need for hospital care for those unable to pay for treatment. Times were hard, especially for the new wave of immigrants who often had to settle for low-paying jobs. Then someone found a purse containing six pennies and came up with the idea of collecting donations of coins from anyone named Mary, and from everyone who wanted to contribute in the name of a friend or family member named Mary.

Soon there was enough money to finance a free bed in the Union Benevolent Association Hospital, later named Blodgett Memorial Hospital. That led to the Mary Free Bed Guild and its army of volunteers called, of course, the Marys. Even the Guild's car, used for transporting patients to and from treatment, was dubbed Mary. From that beginning, the Guild established the Children's Convalescent Home. By 1937, the convalescent home changed its name to the Mary Free Bed Guild Convalescent Home and Orthopedic Center.

In its earlier days, the hospital treated many polio-stricken children, including those in iron lungs. Over the years, it developed into the renowned Mary Free Bed Hospital and Rehabilitation Center, and is an option for people needing short-term rehabilitation from surgeries including knee or hip replacements. It is also a facility for intense rehab including care for those who have suffered strokes or are victims of spinal cord injuries.

Though the beds are not free, the name remains unchanged. The hospital still offers first-class rehabilitation care, and all because in 1891, some generous people knew and loved women named Mary. In 1945, from left: Mrs. Frank Neuman (guild member), Delmar Wood, Dennis Davies, Rose Goldenberg, Mrs. Francis Grimes (guild member), Wayne Wise, Bobby Vaughan, and Billy Bengry.

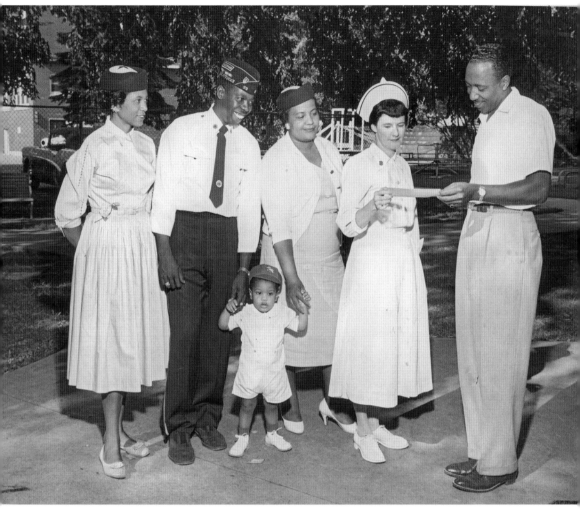

Crispus Attucks American Legion Post

As word of the Mary Free Guild Hospital and Rehabilitation Center spread, it became a popular cause, and the recipient of donations far beyond the initial Mary connection. With polio cases rising, especially among children, people wanted to help and engaged in fundraising activities. The Crispus Attucks American Legion Post added the Mary Free Guild to its list of worthy charities. Members of the post are shown presenting a check to Mary Free Bed nurse, Eulodia Sawyer. From left: Jennie Wade, Art Williams, Jessie Van Burn, Sawyer, and Ray Jackson. The child's name is unknown.

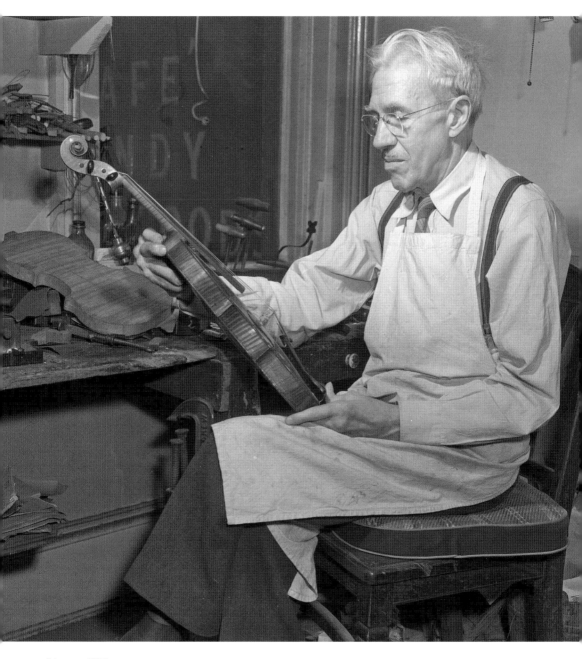

Abram Killinger

Renowned violinmaker Abram Killinger was born on his father's farm in Cass County, Michigan, in 1885. He turned his childhood talent for taking things apart and putting them back together into violin making, and in 1911, he set up shop in Grand Rapids. Killinger-made violins have stood the test of time and are still recognized as superior instruments. The craftsmanship, including a one-piece back, displays physical beauty. Perhaps the greatest reason for the continued reverence for these locally produced instruments is that they possess a distinctive lyrical tone that makes them an ideal choice for classical music. Serious violinists often prefer these handmade pieces over the vast selection of mass-produced instruments.

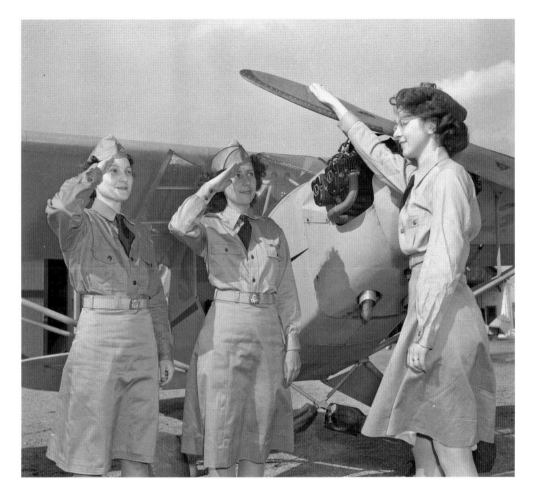

Alice Loomis and the Women's Council for Defense

During wartime, keeping the home front safe from enemy attack has always been as essential as fighting the battles abroad. The Civil Defense Board was created for that purpose, and out of that grew the Women's Council for Defense. Shown here during World War II, Loomis represents the important contributions made by the women of the council. Except for territorial attacks on Pearl Harbor and the Aleutian Islands, the United States was not attacked, but had there been an attempt, the Civil Defense Board and the council were on duty to make sure it was unsuccessful. Women like Loomis were highly trained, wore spiffy uniforms, and stood ready to act should the need arise. Two unidentified volunteers are shown saluting her.

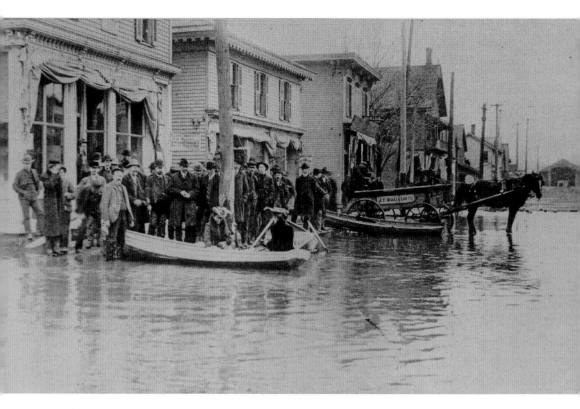

Lithuanian Relief Party
On March 28, 1904, the waters of the Grand River rose an unprecedented 29 1/2 feet. In the resulting flood, 14,000 people were rendered temporarily homeless, and 50 factories were closed, leaving nearly 8,000 people unemployed, some permanently. These residents of the Lithuanian Town neighborhood were among those who volunteered to help those in need. Property damage was extensive and estimated at $1.8 million. Many houses were completely under water. Thousands of people were stranded without food and electricity. Owners of buildings not flooded opened their doors to provide shelter. Miraculously, no lives were lost, and victims looked back on the event as exciting, though taxing at the time. The *Grand Rapids Herald* ran a photograph of a boy and the six-and-a-half-pound catfish he caught in his Turner Street backyard.

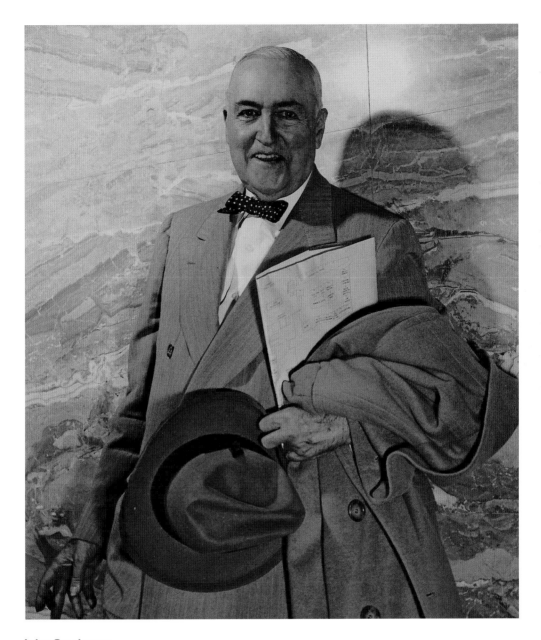

John Cassleman
Residents expected a bleak Christmas in 1935. But that was before John Cassleman, industrial commissioner of what became the Chamber of Commerce, brought hope to the area with the announcement that General Motors would build a stamping plant in the suburb of Wyoming. Secrecy had shrouded the negotiations, with only Cassleman, Grand Rapids mayor/manager George Welsh, and Wyoming supervisor George Tilma in the know. GM officials threatened to stop negotiations immediately if word leaked out. Finally, they sealed the deal, and on December 20th headlines screamed that John Cassleman was giving a GM plant to Grand Rapids. Merry Christmas! That was a remarkable achievement for a man whose formal education ended when he was expelled from high school in his sophomore year. (Courtesy of John Cassleman III.)

Earl Robson

Robson opened his Division Avenue department store just prior to the 1929 crash, and his business grew after the stamping plant was built. When the construction workers needed warm clothing, he invited them to come in and take what they needed. That act of faith turned many of those workers into loyal customers. Everyone who knew Robson had a story to tell, and this image depicts one of many. While traveling in Virginia, Robson had heard the Bearded Beauties and brought them to Grand Rapids. The photo was taken outside Robson's store in 1961. (Courtesy of the Wyoming Historical Commission.)

Spooky

Spooky was a multi-talented German shepherd belonging to bar owner John Sabaitis. In the mid-1930s, he earned his kibble by howling along with the piano player. When he wasn't the star vocalist, Spooky was equipped with a carrier he used to serve beer to the patrons.

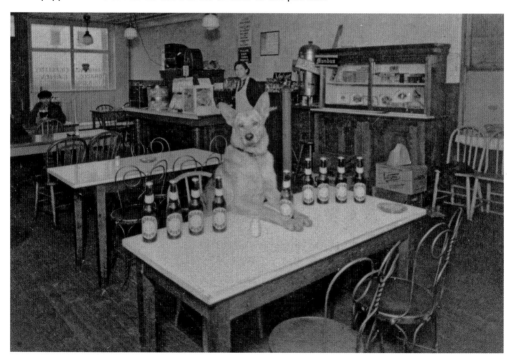

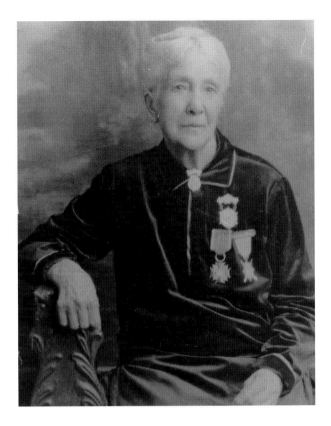

Valeria Lipczynski

Lipczynski immigrated to Grand Rapids in 1869 with her husband, John. Although the Poles later became one of the largest immigrant groups, there were only a few families when they arrived. A potter, John found work in the area known as the Brickyard, and eventually became owner of the Samuel Davis pottery works. The couple had three children, sons Walter and Joseph, and daughter, Helen. Valeria's life work became assisting other Poles.

No matter what else she was involved in, she remained based in her Polish Catholic roots, and was instrumental in the founding of not one, but three, Grand Rapids parishes: St. Mary's, St. Adelbert's, and St. Isadore's. She also recognized the need for the immigrants to socialize together and observe their customs. With John, she organized the city's first Polish Ball, and the Wiarus Society.

John and Valeria sponsored 40 other families who relocated from their village of Tremessen. Valeria gave people one-on-one assistance as well. She was there when illness struck, and even acted as midwife. She tutored children and acted as an interpreter when needed. Because the local authorities respected her and trusted her, they sometimes called on her to act as a pseudo parole officer when other Poles had minor skirmishes with the law.

Despite her love for her homeland, she was fiercely loyal to her adopted country. Toward that end, she encouraged other Poles to support the United States during World War I by contributing to the Red Cross, and by buying bonds to finance the war. The Lipczynski home became a gathering place for Polish relief efforts, and was a depository for clothing and supplies.

Among many firsts, she was the first woman to serve on the board of directors of the Polish National Alliance. That recognition came in 1901. Twenty-six years later she received the Golden Cross of Merit from the Polish government. In 2011, she was inducted in the Michigan Women's Hall of Fame. The Queen of the Poles, Lipczynski died in 1930, outliving her beloved husband by 13 years. Her devotion to the Polish community never wavered.

Arthur Vandenberg

Vandenberg was born in 1884 in Grand Rapids and studied law at the University of Michigan. For more than 20 years, he worked for the *Grand Rapids Herald*, first as a reporter, then editor, and finally publisher. In 1928, Governor Fred Green appointed him to fill the vacancy that occurred upon the death of Senator Woodbridge Ferris. The Republican senator was re-elected and remained in office until his death in 1951. Formerly an isolationist, he changed his position following the attack on Pearl Harbor. Vandenberg worked as chairman of the Senate Foreign Relations Committee, where he was able to forge bipartisan support for the Marshall Plan and the North Atlantic Treaty Organization (NATO).

Meindert De Jong

Brothers Meindert and David Cornel De Jong immigrated to Grand Rapids during childhood from the Friesian Province of the Netherlands. Meindert received Newberry Honor Awards for three of his children's books, *Shadrach, Hurry Home Candy,* and *Along Came a Dog.* He received the Newberry Medal the following year for *The Wheel on the School.* In 1962, he became the first American to receive the Hans Christian Andersen Award for children's literature. (Courtesy of Calvin College, Heritage Hall.)

David Cornel De Jong

Also a prolific writer, David wrote children's books and critically acclaimed novels. His short stories and poetry were published in the top magazines of the day, including the *Atlantic Monthly* and *Esquire.* His most famous work, the novel *Belly Fulla Straw,* was based on his experience as an immigrant beginning at age 13 in 1905. (Courtesy of Calvin College, Heritage Hall.)

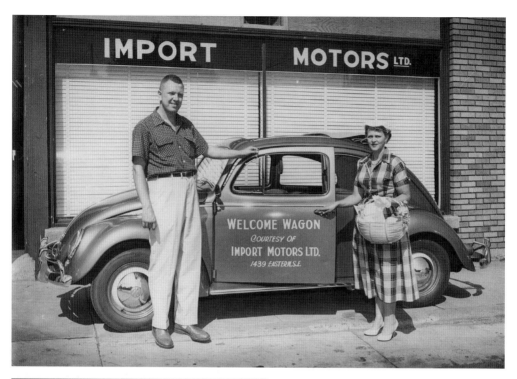

Peter C. Cook

Cook came of age during the Depression and learned the values he credited with his later success. While working at the Kelvinator factory for 17 cents an hour, he noticed his supervisor had to stay late and clean hoses and other equipment. Though he wasn't paid, Cook began helping. That work ethic got him promoted to line supervisor. During that time, he attended Davenport College at night. Eventually, he opened a car dealership and expanded it to include more than a hundred dealerships under the name Mazda Great Lakes. He became a major donor to local educational, medical, and arts institutions. The Cook Clock Tower at Grand Valley State University is just one of Peter Cook's philanthropic contributions. In the upper image, Peter and his wife Pat stand in the showroom of their first dealership. (Upper image courtesy of Cook Holdings; lower photography by Jay de Vries.)

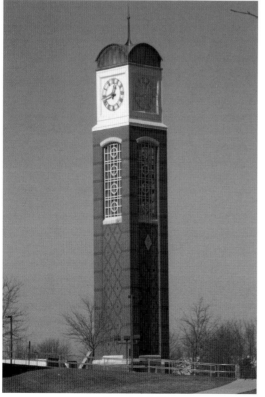

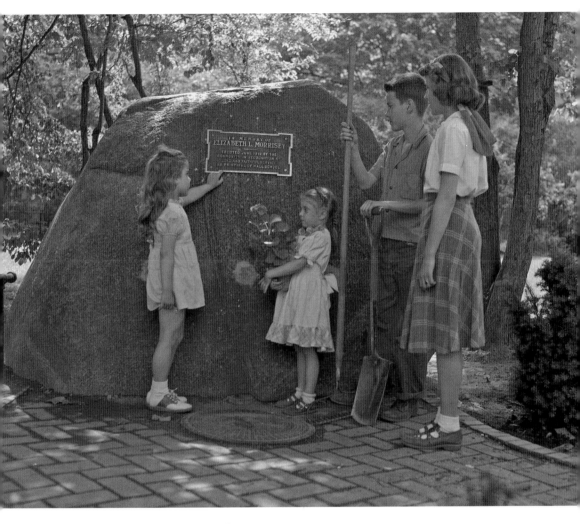

Elizabeth Morrisey Memorial Rock

What is even better than an educator who inspires her students? A community that appreciates the priceless gift of her influence. Elizabeth Morrisey was such an educator, and a year after her 1918 death the Hall School honored her with a memorial rock. Morrisey had spent her career at the school, first teaching, then serving as principal for 25 years. During her tenure, she watched the school quadruple in size, going from four classrooms to 17. Thirty years after the memorial was dedicated, students participated an outside cleanup project that included renovating the rock. Perhaps Morrisey taught the parents of one or more of them. From left are Susan Scheneman, Bess Ann Laible, David Hall, and Shirley Buist.

Hugh J. Gray
Gray turned West Michigan into a tourist hotspot when he became manager of the Michigan Tourist and Resort Association in 1917. He recruited members, attended trade shows to educate people about Michigan's endless recreational possibilities, and traveled the Midwest placing ads and articles selling Michigan as a destination. He worked both sides, forever encouraging business owners to upgrade their service. Gray did not just want people to come once; he wanted to make sure they were tempted to return. His work paid off, and other industries benefited from the influx of people. Now tourism is the second largest industry and The Dean of Michigan Tourist Activity paved the way.

Joan Everson

At age four, Everson fell through the river ice and never forgot her panic or the off-duty policeman who pulled her to safety. She vowed to become a nurse and help people too. Her niece, Terri, reports Joan rescued a young boy who got in over his head in Lake Michigan and gave him artificial respiration. The boy survived. Shown here during childhood, Joan is in the front row with her brother, Robert. From left (back row) father Joel, sister Caroline, mother Genevieve, and brother Jackson. (Courtesy of Terri Vandenhoven.)

Jess Elster

Elster was an early promoter of baseball among the city's black community and was a player and manager before becoming a sponsor. His All Stars played other black teams around the Midwest and had a loyal following. They played home games at Bigelow Field. The Negro Baseball League ended in the 1940s when the major league teams became racially integrated.

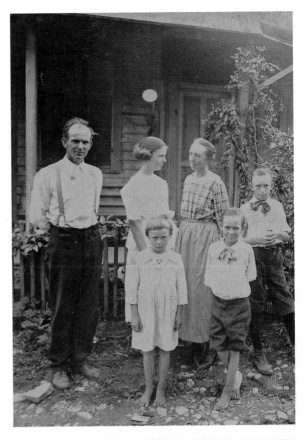

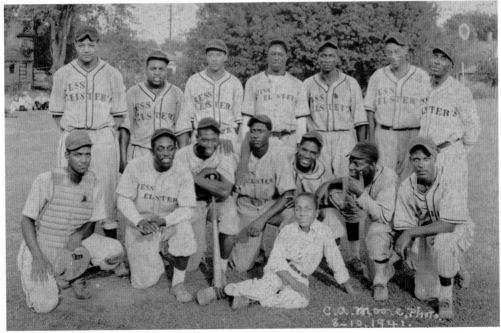

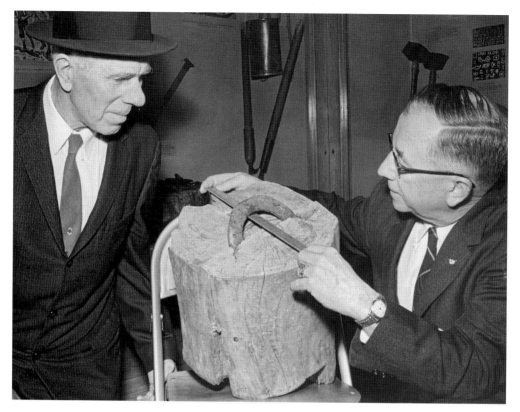

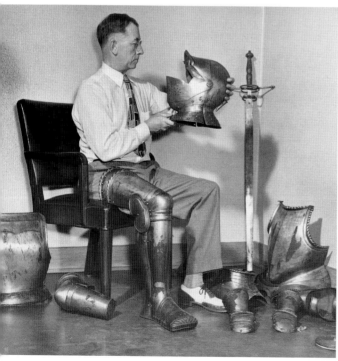

Frank DuMond

DuMond came to the museum in 1923, when it was still called the Kent Scientific Institute. He stayed four decades, and under his direction, the museum flourished and was well on its way to becoming the renowned institution it is today. Part of his success stemmed from his management style, which included mentoring, and inspired great loyalty from those in his employ. At his left in the upper image is Dr. E. Oosterhouse. Always a hands-on administrator, DuMond stopped at almost nothing to impress upon visitors that museums are fun, and to dispel any perception that they are dusty repositories of boring collections. Toward that end, he is shown in the lower image donning a museum acquisition, a coat of armor. (Both images are Courtesy of the Public Museum, Grand Rapids.)

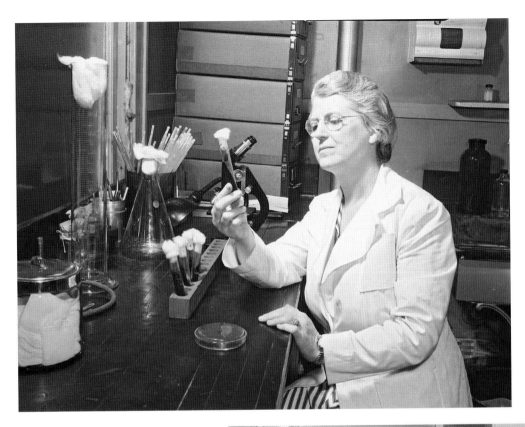

Dr. Pearl Kendrick and Dr. Grace Eldering

It would be impossible to estimate the number of childhood deaths prevented by two Grand Rapids medical researchers. In the 1930s, research scientist Dr. Grace Eldering (looking into her microscope), along with bacteriologist Dr. Pearl Kendrick, developed the first successful whooping cough vaccine. Prior to 1940, when the state of Michigan began producing and distributing it, the disease was the cause of approximately 6,000 childhood deaths per year. The two were unwilling to stop with what some would have considered a major accomplishment. Instead, they continued their research until they were able to combine their original vaccine with diphtheria and tetanus vaccines to form the single shot DPT, still in use today, and still protecting children from what were once dreaded life-threatening diseases.

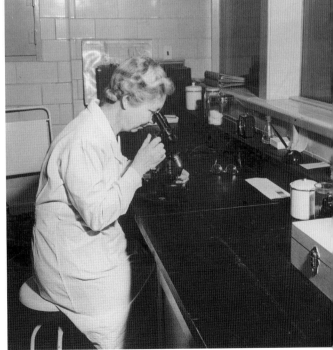

63

Ransome Roberts

Roberts had no children of his own, but his two nephews lived next door and he saw how badly they wanted a bicycle. It was 1936, and people still suffered the effects of the Depression. Roberts and his brother Gerald were making ends meet, but there was no money left for bikes. Though he had little extra money, he did have a talent for fixing things, and found two old bikes to repair for the boys. But it saddened him that the other neighborhood kids didn't have bikes either, so he put out the word that he needed old ones to restore. Soon his garage was full of battered bikes and of kids helping him work on them. They called him Uncle Ranny, just as his nephews did, and he was the most loved man in his Southeast neighborhood. (Courtesy of Janet Kelley-Atkinson.)

Fannie Boylan

Boylan and her husband, Fred, brought complementary talents to their construction business in the early decades of the 20th century: Fannie designed houses, and Fred built them. Her designs were cutting edge and included at least six models that qualified for the Electric Club of Grand Rapids's Red Seal Electric Home designation. She strove for energy efficiency and ease of household chores, particularly in the kitchen. In Fannie's houses, buyers found an abundance of both storage space and electrical outlets. Other innovations included built-in appliances, fans, and ironing boards. The couple showed appreciation for their buyers, employees, and suppliers by hosting an elaborate annual picnic on Big Crooked Lake. One picnic guest said Boylan was shorthand for Buoyancy, Optimism, Youth, Loyalty, Opportunity, and Necessity. It was an apt description. Boylan-built houses can be seen in the city's Southeast side and in the Heritage Hill neighborhood. (Courtesy of Kathy Boylan.)

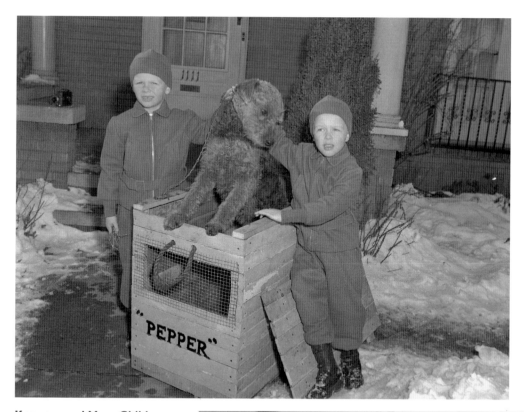

Kearney and Myer Children
Even children were expected to make sacrifices during World War II. Some saw their fathers go off to war. Some had mothers who had gone to work in a factory producing goods needed for the war effort. At the very least, shortages of basic pantry staples meant they could no longer count on enjoying their favorite cookies and other treats. A few even had to sacrifice their beloved pets. The Army needed dogs. With patriotism at an all-time high, it was an honor, though a painful one, when working breeds were drafted. These children are preparing to say goodbye. At the top are Charles and Tommy Kearney with their Airedale terrier, Pepper. In the lower image, the Myer children are sending their German shepherd to be trained for war.

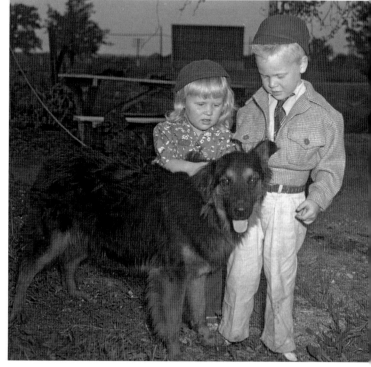

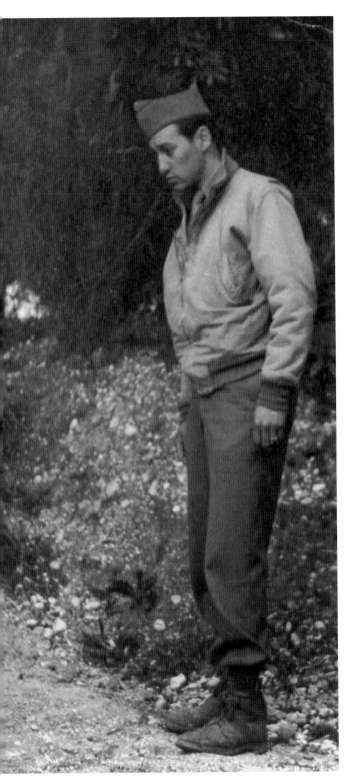

Virgil Westdale

Born Virgil Nishimura to a Japanese father and American mother, Westdale took pilot training in 1941 while still in college, but dropped out when Japan bombed Pearl Harbor. He then joined the civilian War Training Services, where he finished flight training at the top of the class. Imagine his surprise when, because his father was Japanese, he had to surrender his pilot's license. His sister wrote to First Lady Eleanor Roosevelt saying that it seemed like a waste of talent and money not utilizing Virgil's flying expertise. After being thoroughly investigated, his license was restored, but he had already been assigned to the all-Japanese 442nd Army Regimental Combat Team of the Army Air Corps. Joining the regiment gave him his first exposure to Asians other than his father.

He changed his name to prevent future problems (Westdale is a loose translation of Nishimura). The 442nd became the most decorated regiment in military history, often referred to as the Purple Heart Battalion. Among the other heroic deeds of these men, they shot the locks off the gates of Dachau concentration camps and liberated the prisoners within. Westdale is standing at one of the camps in April of 1945.

His second career was in the printing machinery industry, and he worked first for the Burroughs Corporation, then Addressograph Multigraph International. His innovations earned him 25 patents. All work and no play did not make Virgil Westdale a dull boy, as he continued ballroom dancing, a pursuit he enjoyed for most of his adult life, and at which he excelled. Though his 2010 book *Blue Skies and Thunder,* cowritten with Stephanie A. Gerdes, told of his incredible life, the name Westdale was already well known in Grand Rapids. His brother Leonard founded the Westdale Realty Company.

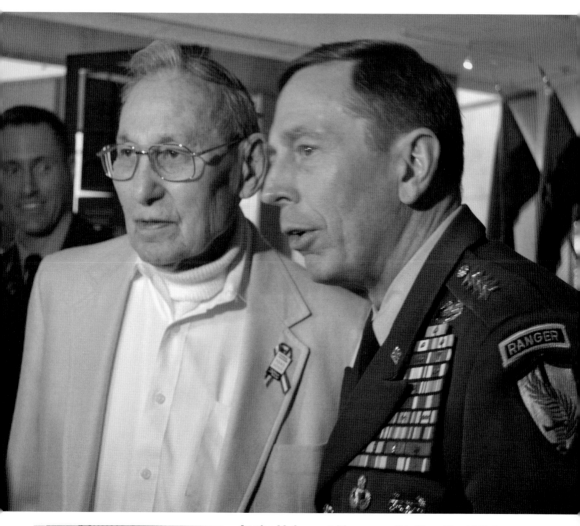

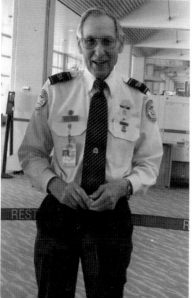

At the Holocaust Museum with Gen. David Petraeus
Virgil visited the Holocaust Museum with Gen. David Petraeus in what must have been an emotional roller coaster made up of pride that he helped win the war, along with sorrow that the atrocities happened. He has little patience with those who deny the Holocaust, saying, 'I was there and saw it'.

Transportation Security Administration Officer
At age 77, Virgil Westdale embarked upon yet another career, that of Transportation Security Administration officer at the Gerald Ford International Airport in Grand Rapids. (All three images courtesy of Virgil Westdale.)

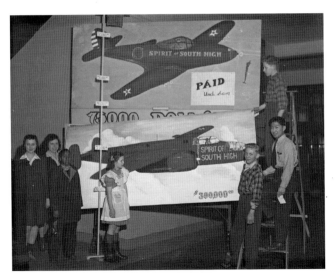

Students of South High, 1943

While any number of high schools were involved in the war effort, South High School may be the only one that bought a bomber. The student body intended to raise $75,000, a goal they soon raised to $375,000. By February of 1943 they had more than enough money to buy a B-17 bomber. Students on the left are, from left: Mary Toarmina, Ruth Ann Jenkins, Chester Ward, and Lois Night. On the right: Arthur Blackport, James Seino Jr., and Melvin Hartger at the top.

Spirit of South High Christening Ceremony

On April 2, 1943, Col. A.C. Foulk piloted the bomber from Columbus, Ohio, to the Kent County Airport in Grand Rapids for its christening. On hand for the event were from left, Foulk, South High Queen LaVonne Kronberg, unidentified, and Harry J. Brown, chairman of the Kent County Retailers War Savings Committee.

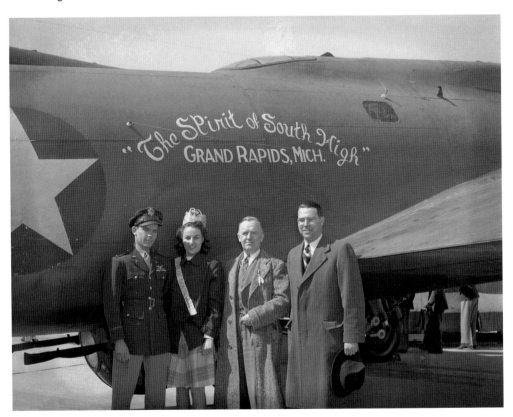

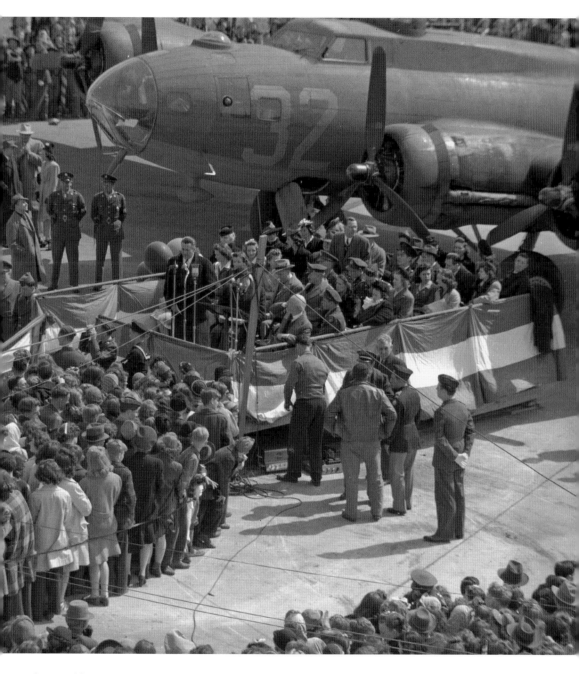

Spirit of South High
A crowd gathered for the April 6, 1943, christening of the *Spirit of South High*. Loud cheers rang out after South High School Queen LaVonne Kronberg, shown on the preceding page, did the honors and smashed the bottle of champagne. The bomber was a reality, and the amazing student body had pulled it off.

Roberta Griffith

Though blinded in early childhood, Griffith was determined to live as independently as possible. After attending schools for the blind, she went to Western Reserve University. She worked as a real estate agent, and as a writer, and designed her own house, a house she would never see. Her greatest accomplishments came from her unceasing efforts to prevent blindness, and to help those already stricken enjoy full lives. In 1913, she helped persuade the Michigan state legislature to require the use of nitrate of silver as an antiseptic in newborn's eyes, thus saving the sight of untold numbers of infants. Griffith also compiled a six-volume Braille dictionary, though three volumes were destroyed when the city reservoir broke and flooded her house.

Reynold Weidenaar

Grand Rapids has its own Dutch master. Weidenaar was born in the city in 1915 and studied art at the Kendall School of Design before spending two years with Jackson Lee Nesbitt in Kansas City. A Guggenheim Fellowship and a Louis Comfort Tiffany scholarship gave him the means to travel, and his time in Mexico greatly influenced his work. Weidenaar is known for his mezzotint prints. (Courtesy of Calvin College, Heritage Hall.)

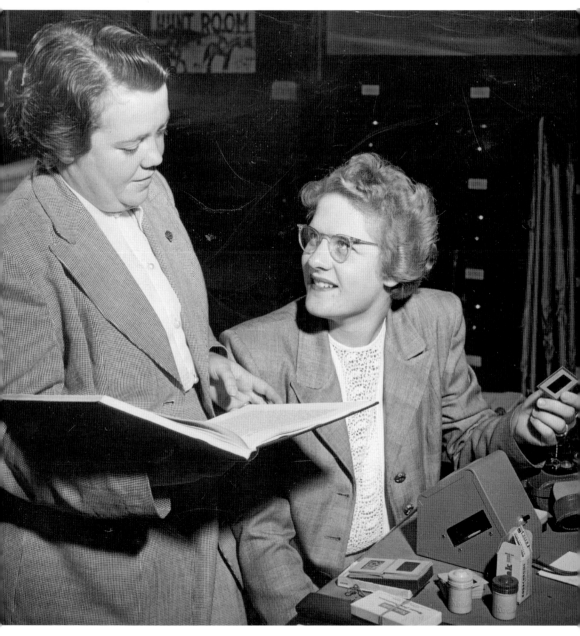

Norma Raby

Raby was a mainstay at the Public Museum, having spent her life there, first as a volunteer from age 12, and then as an employee. In 1940, she led the expansion of educational offerings, and developed a collection of photographs, slides, and filmstrips, often traveling the country to add to the treasure trove. Nothing pleased her more than sharing her finds with curator Mary Jane Dockeray. (Courtesy of the Public Museum, Grand Rapids.)

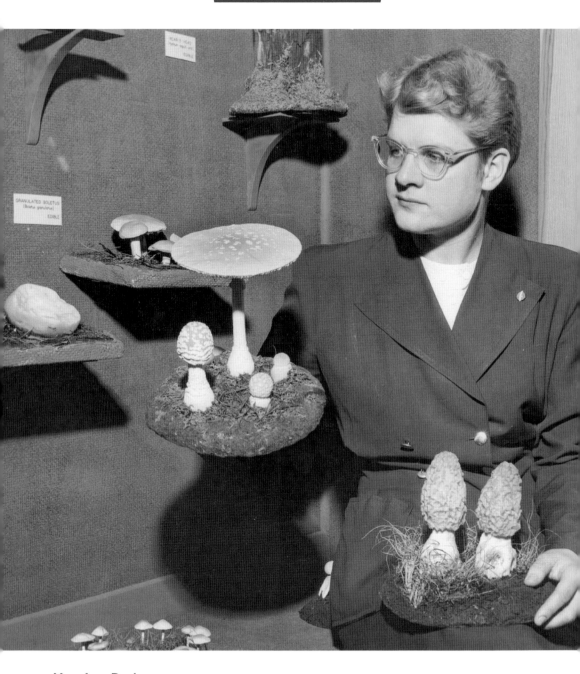

Mary Jane Dockeray

Dockeray worked summers at the Public Museum during her Michigan State University years, and upon graduation was hired as curator of natural history. One of her responsibilities was taking the museum to schools. Toward that end, she developed more than one hundred programs that brought natural history to the classroom. Her love of nature and concern for the environment led her to be at the right place at the right time. When Victor Blandford expressed interest in donating land for a park, she envisioned a nature center. With the support of the museum, the Blandford Nature Center came to be. She is pictured above working with wild mushrooms. (Courtesy of the Public Museum, Grand Rapids.)

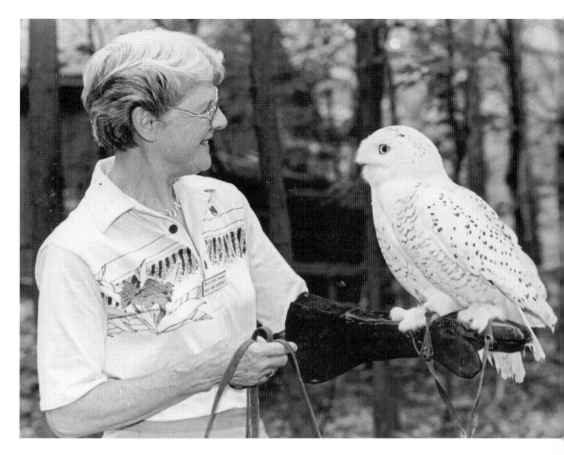

White Owl at Blandford Nature Center

Early in her life, Mary Jane Dockeray made a conscious decision to remain single, feeling she could not have the career she longed for without shortchanging a husband and children. Her legacy will be the Blandford Nature Center. Under her direction, it grew to include day camps, classes, and much more, while still celebrating maple sugaring and other events popular with both groups and individuals. Until her retirement, Mary Jane was the center's heart, and future generations will appreciate her labor of love. She is still a regular volunteer, often seen on the grounds enjoying the wildlife she loved, including this white owl. (Courtesy of the Public Museum, Grand Rapids.)

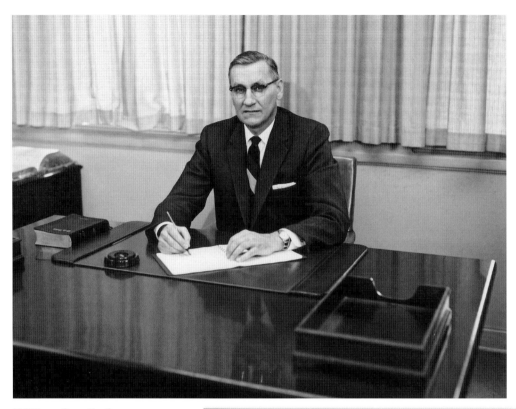

William Spoelhof

In 1951, Spoelhof became the eighth president of his alma mater, Calvin College, and held the position until his retirement in 1976. Even after retirement, he was a familiar figure on campus, visiting faculty and talking with students. Under his direction, the college experienced tremendous growth and built and moved to its present Knollcrest campus on East Beltline. As a son of Dutch immigrants, Spoelhof was a good choice for his World War II duty, working with the Office of Strategic Services in the Netherlands. That led to the 1952 visit from Juliana, Queen of the Netherlands, and her husband, Prince Bernhard. In the lower image, Spoelhof, left, welcomes the royal couple to Calvin College in 1952. (Both images are courtesy of Calvin College, Heritage Hall.)

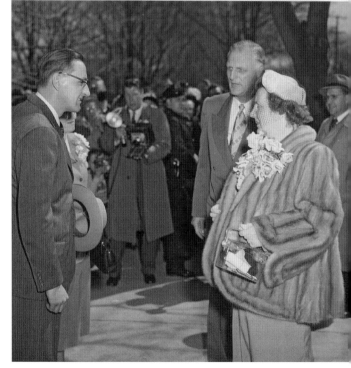

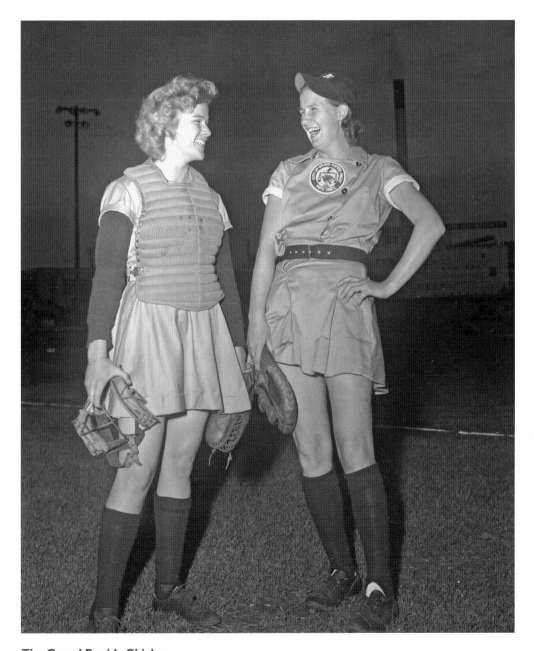

The Grand Rapids Chicks

The Chicks were a team in the All American Girls Professional Baseball League immortalized in the 1992 movie, *A League of Their Own.* Philip Wrigley, of the Wrigley chewing gum company, started the league in 1944 because so many major league players were serving in the military. The Chicks moved to Grand Rapids from Milwaukee a year later, and played until the league ended in 1954. They played their home games at Bigelow Field, and had an enthusiastic fan base. Always qualifying for the playoffs, they brought home championships in 1947 and 1953. Here catcher Ruth Lessing and pitcher Connie Wisniewski smile for the photographers, probably following a strategy conference. In this game, played on May 26, 1946, the Chicks beat the Muskegon Lassies six runs to one.

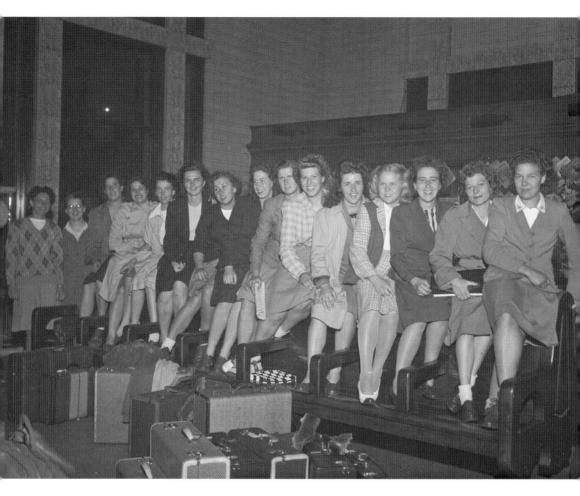

Grand Rapids Chicks 1946 Team
The entire team posed at the train station upon their arrival home from a few days of traveling to away games. Though they occasionally flew to games, most travel was by rail. This image appeared in the *Grand Rapids Herald* on May 21, 1946. From left are Twy Shively, Doris Tetzlaff, Alice Havlett, Phil Francisco, Nancy Warren, Thelma Grambo, Betty Whiting, Elsie Wingrove, Connie Wisniewski, Julie Gutz, Teeny Petras, Pat Keagle, Gabby Ziegler, Vera Whiteman, and Yolande Trillet.

Floyd and Roscoe LaPard (RIGHT)
The LaPard Brothers, Floyd, with the fiddle, and Roscoe at the left with his mandolin, entertained appreciative crowds at area square dances for close to four decades. In addition to their music, they supplemented their income by operating a truck farm and selling fresh produce at local farmers' markets. Unlike most of the other local farmers, the bachelor brothers also made horseradish for grocers in the area. Because they looked so much alike, and sometimes even dressed alike, some of their customers could not tell them apart and called them the Horseradish Twins. This photo was taken in 1947, during the height of their popularity.

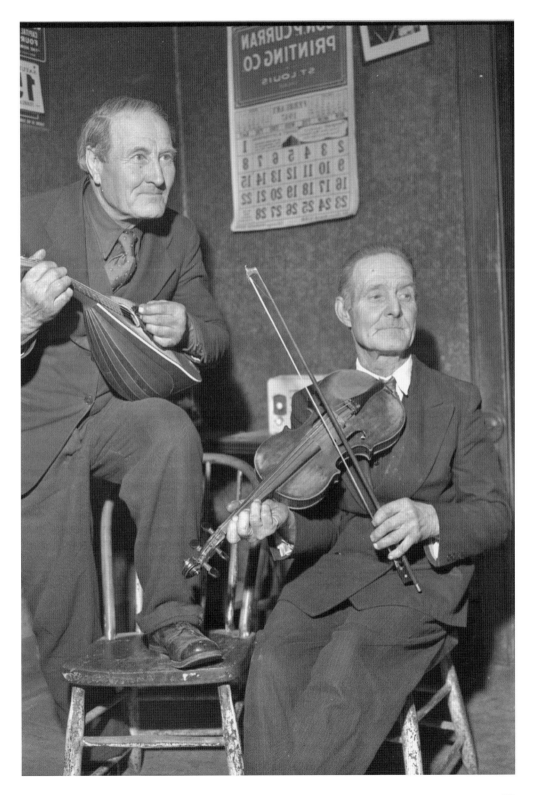

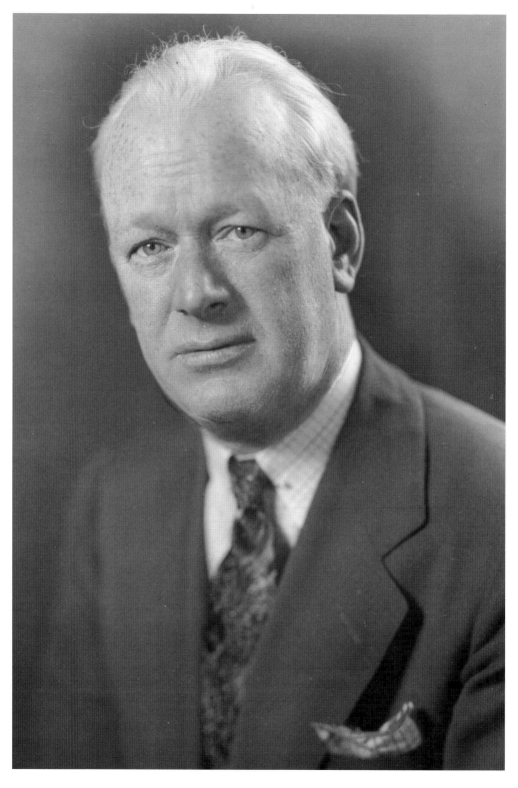

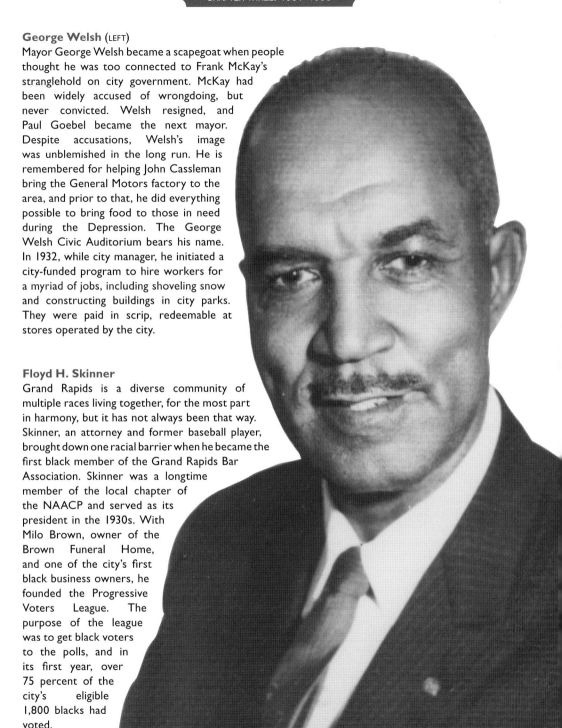

George Welsh (LEFT)

Mayor George Welsh became a scapegoat when people thought he was too connected to Frank McKay's stranglehold on city government. McKay had been widely accused of wrongdoing, but never convicted. Welsh resigned, and Paul Goebel became the next mayor. Despite accusations, Welsh's image was unblemished in the long run. He is remembered for helping John Cassleman bring the General Motors factory to the area, and prior to that, he did everything possible to bring food to those in need during the Depression. The George Welsh Civic Auditorium bears his name. In 1932, while city manager, he initiated a city-funded program to hire workers for a myriad of jobs, including shoveling snow and constructing buildings in city parks. They were paid in scrip, redeemable at stores operated by the city.

Floyd H. Skinner

Grand Rapids is a diverse community of multiple races living together, for the most part in harmony, but it has not always been that way. Skinner, an attorney and former baseball player, brought down one racial barrier when he became the first black member of the Grand Rapids Bar Association. Skinner was a longtime member of the local chapter of the NAACP and served as its president in the 1930s. With Milo Brown, owner of the Brown Funeral Home, and one of the city's first black business owners, he founded the Progressive Voters League. The purpose of the league was to get black voters to the polls, and in its first year, over 75 percent of the city's eligible 1,800 blacks had voted.

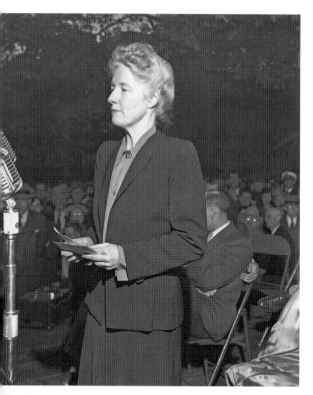

Dorothy Judd

In 1949, Judd zealously (some thought overly so) organized the Citizen's Action Committee to rid city hall of office holders connected to the tainted Frank McKay political machine. Prominent local citizens including Paul Goebel, Duncan Littlefair, and Gerald R. Ford (father of the future president) supported her cause. Her movement gained momentum with housewives wielding brooms to symbolize a clean sweep. In the upper image, she is addressing a rally at Veterans Park. Along with the broom shakers, she inspired sign-carrying protesters to take up what proved to be a successful fight against much of the incumbent city government. Though she never ran for office, Judd remained politically active at the local and state level for almost 70 years.

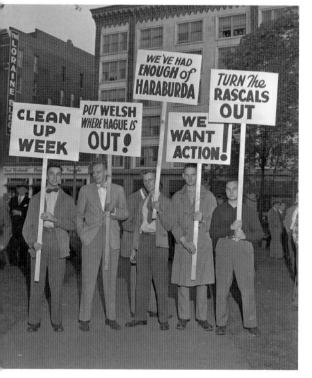

Duncan Littlefair (RIGHT)

Fountain Street Baptist Church called Littlefair to become its pastor in 1944. His preaching proved so controversial that the church soon had to drop the word Baptist from its name, as it was in direct opposition to the denomination's conservative beliefs. Though many embraced his liberal instead of literal Scripture interpretations, and the church grew, others denounced his teachings. Detractors called him Duncan Littlefaith. Far from being intimidated, he thrived on being the center of a storm, and spoke his mind, even to the extent of calling for the resignation of Grand Rapids mayor George Welsh despite the fact that Welsh was a member of his congregation. Littlefair retired from Fountain Street in 1978. (Courtesy of Fountain Street Baptist Church.)

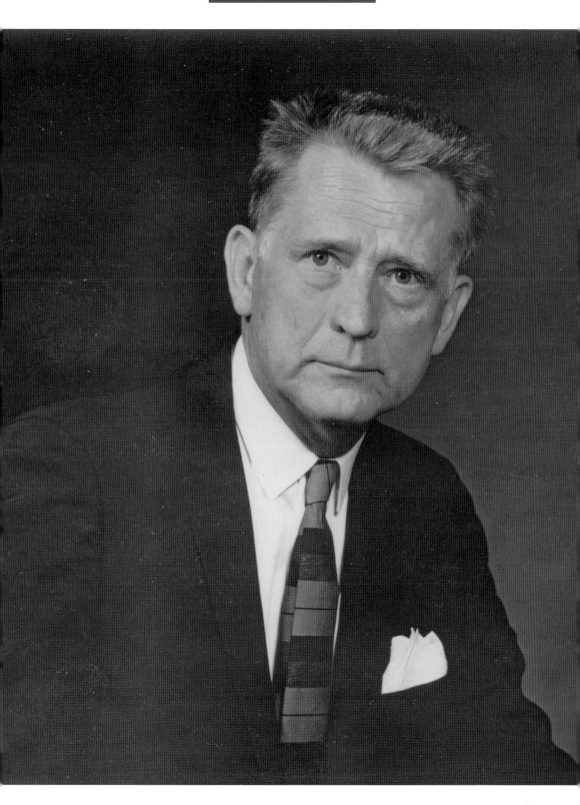

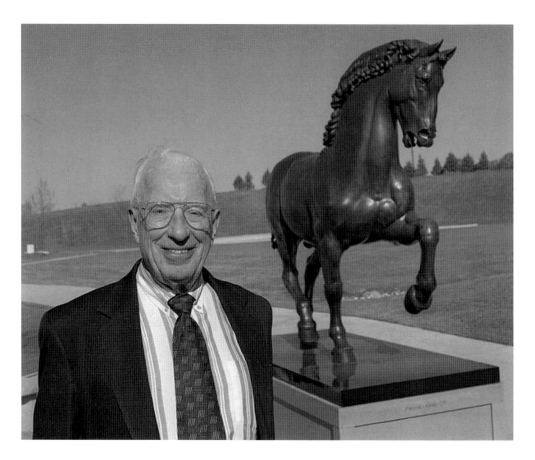

Fred Meijer

Meijer, a one-stop-shopping pioneer, philanthropist, and arts patron, was completely unpretentious and expected no special treatment. With his wife, Lena, he waited in Meijer store flu-shot lines with customers, chatting and passing out Purple Cow ice cream cone coupons. He never forgot his humble beginnings spent working in his father's first store. His greatest legacy is arguably the renowned Meijer Gardens and Sculpture Park. The crown jewel of the facility is the 24-foot bronze horse, the model of which Meijer is pictured beside. Known as Leonardo's horse, da Vinci was to have created it in the late 15th century in Milan, Italy. France invaded Italy and the work was never done. Using da Vinci's sketches and notes, Nina Akamu undertook the enormous project of doing two horses, one of which was installed in Milan, the other, funded by Meijer, at the Gardens. (Courtesy of the Meijer Corporation.)

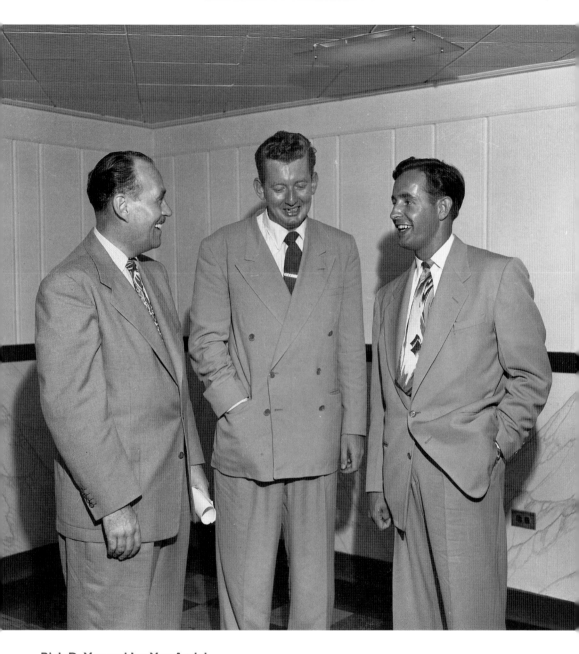

Rich DeVos and Jay Van Andel

DeVos and Van Andel are best known for founding the Amway (American Way) Corporation. The company has been hugely successful, and the partners and their families have contributed much to the community in terms of medical and educational facilities, along with entertainment venues. Grand Rapids has become nationally known for its first-rate medical research and treatment facilities. The names DeVos or Van Andel appear on buildings in the burgeoning health care corridor. DeVos Hall and Van Andel Arena add to the name recognition factor. Lesser known are the quiet acts of generosity of these two prominent families. One example is the rebuilding of the Ada historic covered bridge when it was destroyed by fire in the late 1970s.

Helen DeVos

To many, Helen DeVos is Rich's wife or the name on the Children's Hospital. The hospital demonstrates her dedication to helping children, but few know of the charitable work she performs away from home. She became interested in the Christian Reformed missions in Rehoboth and Zuni, New Mexico, through Calvin College classmate, Roland Kamps. While visiting Zuni in 2010, she noticed women baking ceremonial bread in an outdoor oven and asked to join them. Children, celebrating the last day of school, were curious but shy. Helen DeVos is a former teacher and quickly won them over with her characteristic warmth. A few years earlier, Helen and Rich had helped build a gymnasium at the Rehoboth Christian School. Upon learning a new school was needed in Zuni for the Native American students, they became lead contributors to the project. (Courtesy of the DeVos Foundation.)

CHAPTER FOUR

1951–1980

These years brought dramatic change both on the world stage and at home. Dwight D. Eisenhower initiated the space program. Gerald Ford became a congressman and began a climb to prominence that, by an unprecedented series of events, led to the Oval Office.

The space program came into fruition during the JFK years and brought into American living rooms what had once been the stuff of science fiction. Fantasy and reality collided in 1970 when the Apollo 13 space crew sent the famous "Houston, we have a problem" message. In the ensuing days, television viewers could follow the drama, or watch the fictional *Lost in Space* show. The Apollo support crew included Grand Rapids's own Jack Lousma. He was the second homegrown astronaut, following Roger B. Chaffee, who perished in a launch pad fire with Virgil "Gus" Grissom and Edward White. Richard Nixon was president when Neil Armstrong walked on the moon.

The Korean Conflict ended. The Cold War escalated. Vietnam divided the nation. But life went on. Sports matter now and mattered then. Tiger pitcher Dave Rozema went to Detroit, Marion Ladewig continued winning bowling tournaments, and Scott McNeal started what would become the annual Gus Macker basketball event. Martin Morales tried riding a horse into city hall to make a political point, and Del Shannon rocked with hits including Runaway. The last words of a song popular at the time provided an apt description: Those were the days, oh yes, those were the days.

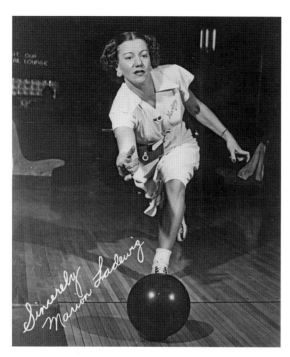

Marion Ladewig

Most consider Ladewig the greatest female bowler ever. When she became a pinsetter at the Fanatorium Bowling Center on Jefferson Avenue, owner William Morrissey saw her natural talent and trained her. In 1951, she became the only woman to win city, state, and national all-event titles in one year. In the years 1950–63, she was named Bowler of the Year nine times by the Bowling Writers of America. After retiring from the pro circuit in 1964, she joined Warren Reynolds on the WOTV Bowling Classic. Her Hall of Fame honors include the Women's Sports Hall of Fame in New York, the National Bowling Hall of Fame in St. Louis, the Michigan Hall of Fame, and the Grand Rapids Sports Hall of Fame. Marion demonstrates her perfect form in the upper image, and gives her daughter LaVonne some pointers in the lower one.

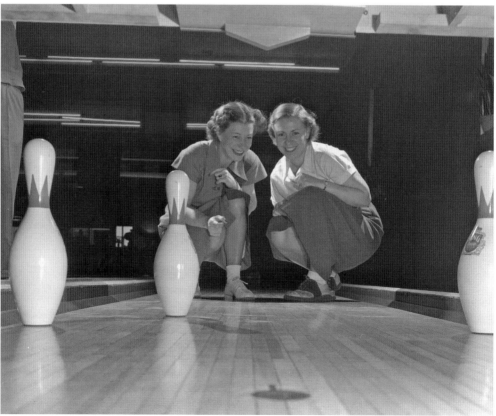

Del Shannon
Shannon, whose real name was Charles Weedon Westover, was born in Grand Rapids on December 30, 1934, and grew up in nearby Coopersville where he began playing guitar. One of Shannon's early influences was country favorite Hank Williams. He rose to rock star fame in 1961–62 with multiple hits including the one for which he is still best known, Runaway. By 1963, his career had temporarily stalled in the United States, but he enjoyed success in Britain. Despite ups and downs, Shannon remained active in the business for nearly 30 years. It all came to an end on February 8, 1990, when personal problems led to depression, and he committed suicide at his home in Santa Clarita, California. Coopersville keeps his memory alive with an annual Del Shannon Festival and car show. (Courtesy of the Del Shannon Fan Club.)

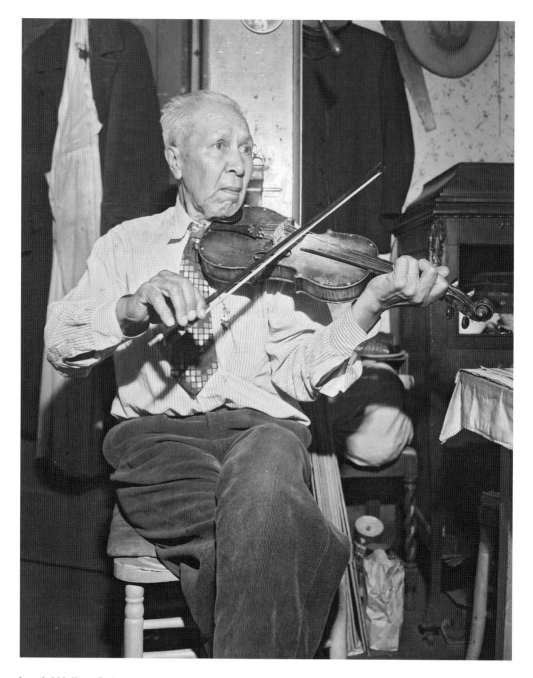

Jacob Walker Cobmoosa

Native American Jacob Walker Cobmoosa, a direct descendant of Ottawa Chief Cobmoosa, was a carpenter by trade and a violinist by choice. In his capacity as attorney-in-fact for the Michigan Ottawa and Chippewa tribes, the Carlisle University graduate petitioned the Commissioner of Indian Affairs division of the US Interior Department to settle a claim of $68 million he believed was due the tribes under the Treaty of July 31, 1855. Before the case went to trial, Cobmoosa died on July 17, 1951. No one else took up the cause, so it was later dismissed due to lack of prosecution.

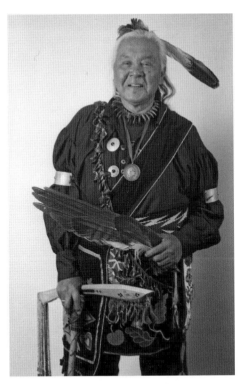

Isaac Peter

Peter's ancestors flourished in Grand Rapids more than three centuries ago, and he is proud to keep their culture alive. One way he does this is by leading the opening ceremonies at the annual Grand Valley Powwow. He especially cherishes the peace medal he's wearing around his neck, as it was a gift to his great-great-grandfather from Pres. Millard Fillmore in 1852.

Walter Coe

Coe was already known in baseball circles, having played for both the Colored Athletics and the Black Sox. He made history when, in 1922, he became the city's first black police officer. Any doubts of his abilities were laid to rest when Coe quickly moved up the ranks. In two years, the recruit worked his way up to sergeant. In 10 years, he made lieutenant. By retirement, he was detective and captain of the Special Investigation Division. Coe is pictured in 1953 with his wife Ethel, and daughters Joyce (left) and Marlene.

Joseph Cizauskas

Cizauskas hated his nickname, Indian Joe. The Lithuanian immigrant arrived in Grand Rapids shortly after World War I. He worked in his brother's store, and later for Wolverine Worldwide in Rockford, but was best known for his zeal to preserve wildlife and protect his land. Cizauskas bought up property around Pickerel Lake until he owned 235 acres. To support himself, he grew Christmas trees for sale and operated a small boat livery. Intruders were kept away with Don't Kill the Rattle Snakes signs. Because he didn't trust banks, he buried money in jars and teapots. After his death more than $11,000 in cash, and about $3,400 in government bonds were found and given to his sister. Cizauskas had one wish: That his property be turned into a nature preserve. Fred Meijer made it happen by donating funds to create what is now called the Pickerel Lake Fred Meijer Nature Preserve.

Dick Ter Maat

In 1966, Ter Maat accepted a call to the Ninth Reformed Church in a poverty-stricken neighborhood comprised of whites, blacks, and Latinos in the West Side of Grand Rapids. Gang activity was a problem, and few of the houses were owner-occupied. It was a large order, but Reverend Ter Maat was up for the challenge. When he couldn't get young people to come to the church, he created the Otherway Mission, and took the church to them. With help from the denomination and a few concerned adults, the project far exceeded his initial expectations.

What started as a storefront community activity center where teens could play ping-pong or pool in a safe environment turned into a facility that revitalized the neighborhood. It fostered community. When adults dropped in for coffee and encouragement, they became acquainted with one another. Friendships blossomed. Hope replaced despair, and neighborhood residents dared to explore new possibilities, including job training. An offshoot of the original ministry has successfully turned homeless into renters, and renters into homeowners, thus proving that when given a chance, people are able to rise above themselves and do that which they once thought impossible. Like Habitat for Humanity, the program requires sweat equity. Pride of ownership resulted in painting homes and planting seeds.

With restored faith in God and awakened confidence in themselves, neighbors have proven conclusively the truth of the words from the Book of Proverbs painted on the mural shown above: The influence of Godly citizens causes a city to prosper. (Photograph by Jay de Vries.)

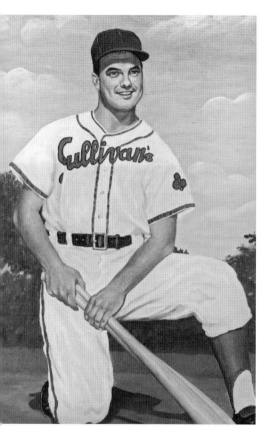

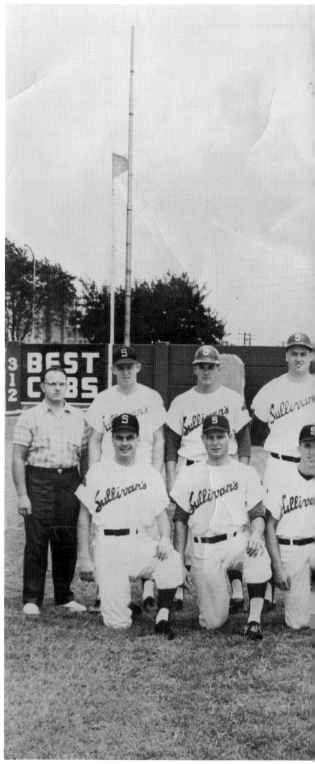

Bob Sullivan

Sullivan may be a successful hotelier and home furnishings retailer, but to many in Grand Rapids, his name means baseball. For 40 years, his American Baseball Congress team, the Sullivans, were a force to be reckoned with, winning the ABC World Series four times. They were six-time winners of the Haarlem Baseball Week in the Netherlands. Some of that can be attributed to talented players, as more than a few major league players first played for the Sullivans, including Jim Kaat, Al Kaline, Willie Horton, and Kirk Gibson. Bob Sullivan never played in the major leagues, but, as a scout for the Detroit Tigers, he helped other players get there, including those mentioned above who played on his team. Mickey Stanley, another player Sullivan scouted for Detroit, played outfield for Sullivan in 1960, one of the years the team won the ABC World Series. (Courtesy of Bob Sullivan.)

Bob Sullivan Portrait

It's fitting that a portrait of Sullivan would show him in a baseball uniform. This is a man whose life has been dominated by the sport. It's also fitting that a ballpark bears his name. The former Valley Field was renamed Sullivan Field, and he built a playground for children across the street from the field. Sullivan has been inducted into five sports halls of fame: The Grand Rapids Sports HOF, the Michigan State Sports HOF, the National Baseball Congress HOF, the Netherlands Baseball HOF (the Sullivans played in the Netherlands thirteen times), and the Michigan Golden Gloves HOF. If that was not enough, Bob Sullivan has three championship rings for his work as a scout for the Detroit Tigers and the Arizona Diamondbacks. (Courtesy of Bob Sullivan.)

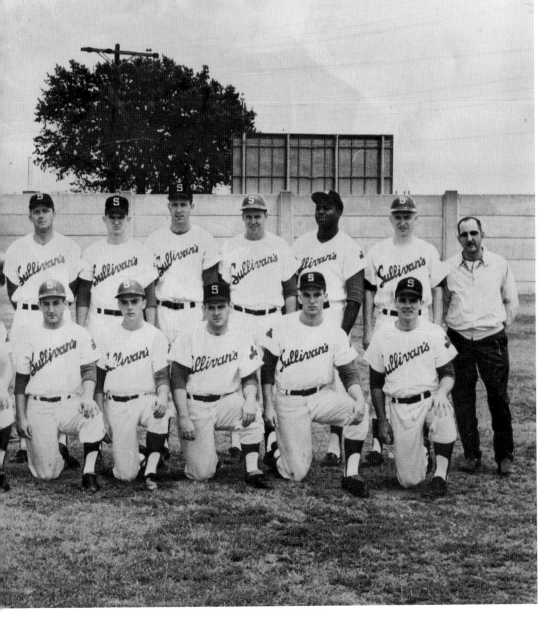

Dr. Ruth Herrick
Along with being one of the first woman physicians in Grand Rapids, Herrick enjoyed many interests including archaeology. She was a lifelong scholar, a collector of Greentown Glass, and a tireless worker for the Public Museum, where many of her various collections are now housed. In 1961, with the Kent County Medical Society, she compiled an historic medical collection and displays. Dr. Herrick died in an automobile accident in 1974, leaving many of her assets to the museum in what, at the time, was the largest bequest to date. (Courtesy of the Public Museum.)

Evangeline Lamberts

Lamberts made history when, in 1961, she became the first Grand Rapids woman to be elected a city commissioner. As her campaign poster shows, she ran on a platform that included progressive thinking. Decades later, one has to wonder how progressive she really was when she ran as Mrs. Austin Lamberts rather than her own given name. Lamberts defeated incumbent Second Ward commissioner Robert Blandford and served one four-year term. She died in 2004, at age 80.

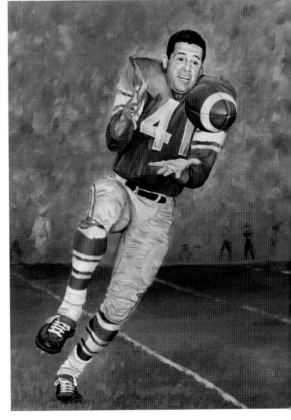

Terry Barr

Before he filled the position of wide receiver for the National Football League's Detroit Lions, Barr attended Central High School and played in the Grand Rapids City League. He spent his entire nine-season career with Detroit, and in his rookie season played in the championship game. Detroit beat Cleveland 59–14. Barr was inducted into both the Michigan and the Grand Rapids Sports Halls of Fame. He died on May 28, 2009, of Alzheimer's disease. (Courtesy of the Grand Rapids Sports Hall of Fame.)

95

Tony Dauksza
People visiting Michigan to fish, hunt, or to enjoy the outdoors might envy someone who lived here. While Tony Dauksza, a second-generation Lithuanian, appreciated the recreational advantages of his home state, he sought greater challenges. Toward that end, he traveled to Alaska and other far-flung destinations where he could see grizzly bears and polar bears and experience pristine wilderness. Dauksza had played football at Union High and had played against Gerald Ford and his South High team. Years later, Dauksza became lost in the Arctic, and his formal sports rival, then Congressman Ford, initiated a search that saved his life. His greatest adventure was a solo canoe expedition following the 3,500-mile Northwest Passage.

Roger B. Chaffee
After Gerald Ford, it's safe to say that Chaffee was the city's favorite son. The nation grieved when Chaffee, along with Virgil "Gus" Grissom and Edward White, perished in a launch pad fire during a flight simulation. In Grand Rapids, the loss was personal. He was a local hero, and his parents Donald and Blanche with whom he is shown at right, still lived in the area. (Courtesy of the Public Museum, Grand Rapids.)

Jack Lousma
Grand Rapids's second entry into the NASA space program was aeronautical engineer Jack R. Lousma. Sometimes called the Flying Dutchman, Lousma logged many hours as an officer in two Marine Corps Air Wings, before spending two months in space as part of the second Skylab crew, and acting as support crew for Apollo 13.(Courtesy of the National Aeronautics and Space Administration.)

97

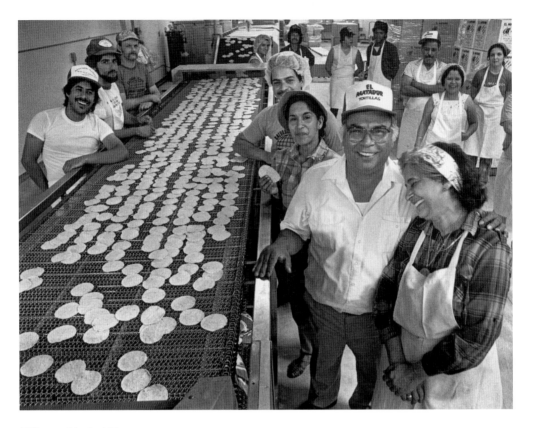

Mike and Isabel Navarro

Miguel (Mike) Navarro came to the Grand Rapids area as a migrant farm worker to pick celery. He stayed, married Isabel, and eventually became a factory owner. With Isabel, shown at his right, he started the El Matador Tortilla factory producing chips for the food service industry. The Navarros expanded the business when restaurant clientele wanted to buy bags of chips to take home. El Matador chips are now sold in supermarkets throughout the region, and at the factory store on Franklin Street. Despite his success, Navarro never left his Roosevelt Park neighborhood, preferring to stay where he was, mentoring other Latinos, and easing assimilation of immigrants. Isabel died on February 7, 2010. Mike's many kindnesses along with his activism made him a beloved role model in the community, though deteriorating health slowed him down until his death on February 26, 2012. (Photo by *Grand Rapids Press*, July 12, 1986.)

Mary Stiles (RIGHT)

Sometimes you have to stand up for what you believe as Mary Stiles is doing here. The tower to which the sign refers was the clock tower on the old Grand Rapids City Hall, and had been an iconic part of the city's landscape since 1888. Stiles was one of many citizens protesting the 1969 plan to level the building when Union Bank needed a parking lot. The protest was doomed, as you can't fight city hall even to save city hall. She chained herself to the wrecking ball in a futile attempt to halt demolition.

Nancy Mulnix

One determined woman, Mulnix was the driving force behind bringing the Alexander Calder stabile, *La Grande Vitesse* (The Grand Swiftness) to the city in 1969. Though it was controversial at the time, to most residents today, it defines the downtown renaissance of the time. It was made possible through private funding and a National Endowment of the Arts public sculpture grant, the first ever given. Images are from the dedication ceremony on June 14, 1969. From left: Lee Mulnix, Michael Mulnix, Bill Gill, Alexander Calder, Esther Seidman, Louisa Calder, Bobby Mulnix, Nancy Mulnix, Klaus Perls, Cissy Mulnix, and Roger Stevens at the far right. The lower image shows the crowd assembled at Vandenberg Center for the event.

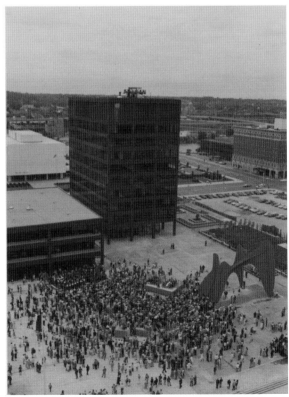

Chris Van Allsburg

A beloved author and illustrator, Van Allsburg is the recipient of numerous awards including two prestigious Caldecott Medals for *Jumanji* (1982) and *Polar Express* (1985). He has enchanted young readers for decades. He wrote and illustrated both books, and both have been made into films. *Polar Express* will continue to be a Christmas classic for years to come. Van Allsburg is currently living in Connecticut. (Courtesy of Houghton Mifflin.)

Greg Meyer

Grand Rapids native and Boston Marathon winner (1983), Meyer has also run numerous other races, including the hometown River Bank Run which he won seven times. Lesser-known achievements include his stint as director of major gifts for the Greater Michigan Region for the University of Michigan, where he raised more than $125 million. He returned to Grand Rapids in 2008 to become associate vice president for Institutional Advancement at Aquinas College. (Courtesy of the Grand Rapids Sports Hall of Fame.)

Bob Becker

During his thirty years with the *Grand Rapids Press*, mostly as sports editor, Becker had a satisfying career. He and his team covered events at the local, state, and national level. That meant attending World Series and other professional championship games, a great gig for a former baseball player. It was not all glitz, however, and Becker was one of the first large city newspaper reporters to cover girls and women's games. Until then, the prevailing attitude was "who cares?" A lot of people cared, it turned out, and Becker and the *Press* can be proud of their part in eradicating that gender bias. In the early 1990s, he brought a women's college tournament to the city that included Marquette University, Notre Dame, University of Michigan, and Michigan State. Nine thousand spectators showed up to watch. In 2010, he was inducted into the Grand Rapids Sports Hall of Fame, a fitting tribute as he was a major force in creating the Hall of Fame.

But ask him what he considers the best thing he ever did and he tells a different story. He credits the Air Force with his journalism career, as he spent his four years of service both playing ball and writing about it for Air Force publications. That left him feeling that others had contributed more. Since his retirement, he has made up for that by spending much of his time working on veteran's issues. Working through the Walter Durkee American Legion Post 311 where he is a trustee, he established Legion Flight 311, a local organization that provided three flights taking West Michigan World War II veterans and their escorts to visit their monument in Washington, DC. When the veterans were located and the trips planned, Becker notified as many family members as he could, and had them send him letters addressed to their veterans that he later distributed. Some broke down and cried when they read their letters. Becker gets emotional himself when describing the trips. He saw firsthand the depth of those heroes' emotional response both to war memories, and to being cheered by the grateful people they encountered while traveling.

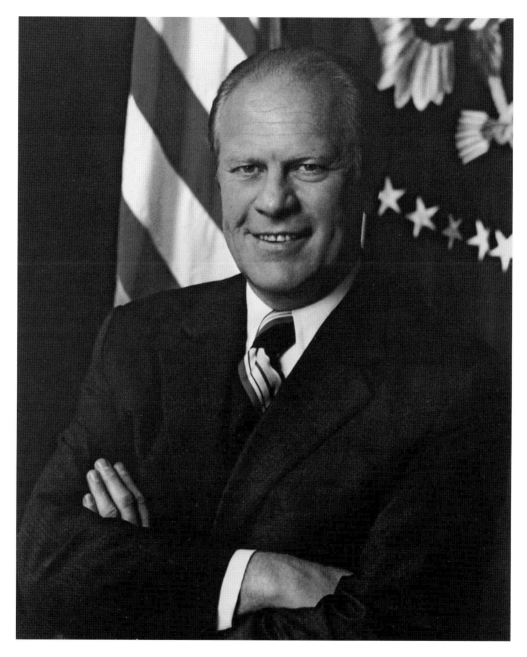

Gerald R. Ford
Any book about Grand Rapids' legends would be incomplete without the inclusion of President Ford. His father, Gerald Ford Sr., owned a paint and varnish business and was active in local politics though never held office. In his later years, Ford reminisced about how politics had changed since his congressional days. As House Minority Leader, he and his Democratic counterpart, who was also his friend, would leave the Capitol in the same car, enjoy lunch together, then ask, "What are we supposed to argue about today?" They discussed the issue rationally, reached a compromise, then rode back to their respective offices to convince their peers. (Courtesy of the Gerald R. Ford Presidential Library.)

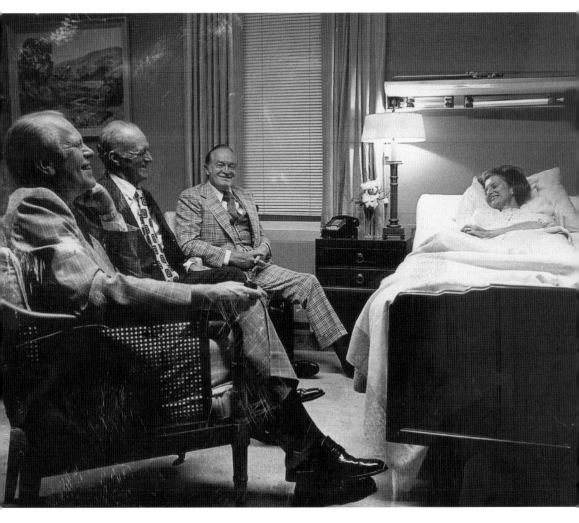

Betty Ford

Betty Ford's personal revelations drew some criticism, but mostly praise. It would be impossible to estimate the number of lives she saved or prolonged by courageously going public with her breast cancer diagnosis at a time when few women did. She raised awareness and urged women to have mammograms. But most would agree that her greatest legacy is the Betty Ford Clinic for alcohol and substance abuse. The former First Lady founded the clinic after refusing to hide her abuse of prescription drugs and alcohol to numb the chronic pain she had suffered from injuries sustained in her professional dancing days. She is shown here recuperating from breast cancer surgery and enjoying a visit from the president, legendary entertainer Bob Hope, and an unnamed visitor. (Courtesy of the Gerald R. Ford Presidential Library.)

Magdalena "Maggie" Garcia

Garcia was born in Chicago, but the family moved back to Mexico when she was three. She started cooking in early childhood, and later worked in various restaurants including the four-star French kitchen at Chicago's Hyatt Regency. When visiting family in Grand Rapids, she knew this was where she wanted to be. She and her husband, Eustacio, started Moctezuma, a wholesale restaurant and grocery supply business to produce authentic seasonings and other products. She started her award-winning restaurant, Maggie's Kitchen, because when she cooked for her family at Moctezuma the customers wanted to buy her food. She still cooks every day, along with her son, grandson, and great-granddaughter, making four generations of family involved in the business. The popularity of the restaurant became apparent by the public outcry when the bar next door wanted to buy her building for expansion. Maggie is shown here with her son Luis on the left, and grandson also Luis. (Photo by Jay de Vries.)

Paul Schrader

The legendary screenwriter and director of *Taxi Driver* and *The Last Temptation of Christ* fame grew up in Grand Rapids and is a Calvin College graduate. A career in the film industry was a stretch for the son of strict Calvinistic parents who saw his first movie at age 17 when he sneaked into the theater without their knowledge. Schrader even minored in theology while at Calvin, and his film *Hardcore* reflects those roots, as does his recurring theme of self-destruction followed by redemption. The protagonist of *Hardcore* is based on Schrader's father, Charles. He found his life's work when he left Michigan and earned a master of arts degree at UCLA, breaking into the industry as a film critic. In 1991, he remembered Calvin College with a donation of his collection of 40 boxes of books about the film industry.

Dave Rozema

Rozema began his rookie season with the Detroit Tigers in 1977. Though part of the 1984 World Series team, he is remembered for suffering self-inflicted injuries. While trying to karate-kick a Minnesota Twins player, he fell and was taken off the field on a stretcher. In another incident, he landed on a bottle of cough medicine in his back pocket and required multiple stitches in his buttocks. (Courtesy of Grand Rapids Sports Hall of Fame.)

Catholic Central High School 1978 Football Team

Norma Lewis's photography class assignment was shooting images of buildings to develop in class. Driving past Catholic Central High School and the Cathedral of St. Andrew, she spotted these football players kneeling on the church steps. Bus motors were running; the team was headed to Bad Axe for the semifinal championship game. The Hail Mary worked for Ted Hollern, number 9, and Steve Passinault, number 20. Catholic Central made it to the final game where they lost to Warren Woods. (Photograph by Norma Lewis.)

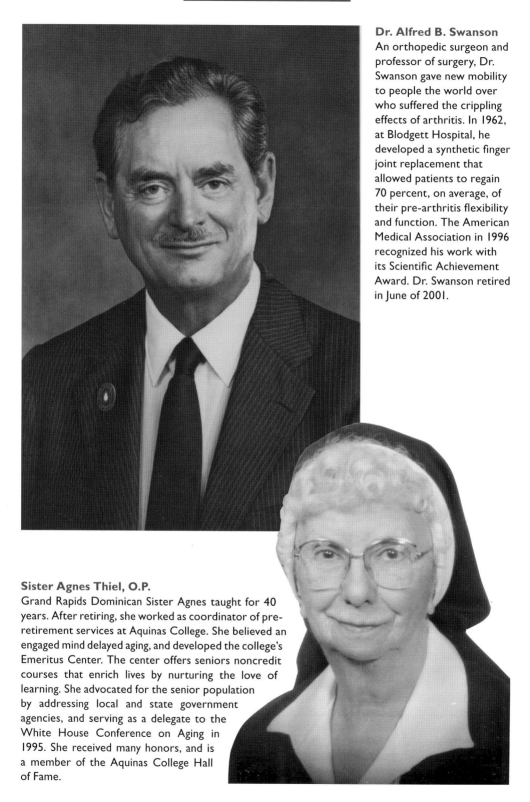

Dr. Alfred B. Swanson
An orthopedic surgeon and professor of surgery, Dr. Swanson gave new mobility to people the world over who suffered the crippling effects of arthritis. In 1962, at Blodgett Hospital, he developed a synthetic finger joint replacement that allowed patients to regain 70 percent, on average, of their pre-arthritis flexibility and function. The American Medical Association in 1996 recognized his work with its Scientific Achievement Award. Dr. Swanson retired in June of 2001.

Sister Agnes Thiel, O.P.
Grand Rapids Dominican Sister Agnes taught for 40 years. After retiring, she worked as coordinator of pre-retirement services at Aquinas College. She believed an engaged mind delayed aging, and developed the college's Emeritus Center. The center offers seniors noncredit courses that enrich lives by nurturing the love of learning. She advocated for the senior population by addressing local and state government agencies, and serving as a delegate to the White House Conference on Aging in 1995. She received many honors, and is a member of the Aquinas College Hall of Fame.

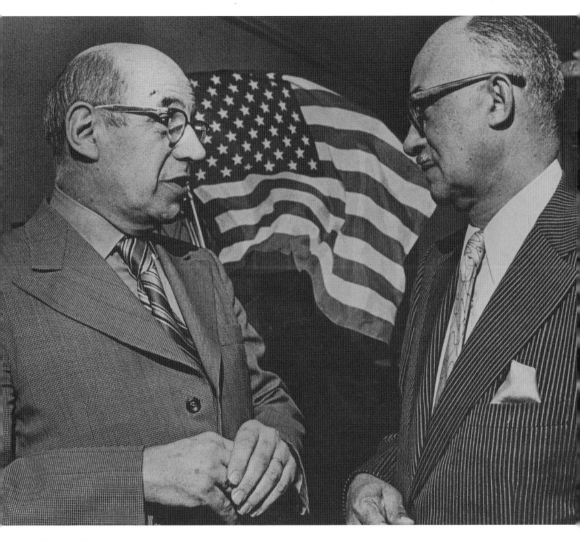

Lyman Parks

Reverend Parks (right), pastor of the First Community African Methodist Episcopal Church, broke racial barriers in 1974 when he became the city's first black elected mayor. From his pulpit, he had been a strong voice to his congregation, and the black community at large, during the 1960s riots. Parks preached that a good education, hard work, and personal responsibility would ultimately trump handouts. Appointed mayor in 1971 following the resignation of incumbent Robert Boelens, he triumphed over nine challengers in the next election, but was defeated by Abe Drasin in 1975. Here Parks, with former mayor Christian Sonneveld, is being sworn in.

Scott McNeal (Gus Macker)

Scott (right) and Mitch (left) McNeal started the Gus Macker three-on-three half court outdoor basketball tournament on their Lowell driveway in 1974, and they have seen the event grow into a national event. Gus Macker is Scott's childhood nickname. Scott was a short kid who wanted to play basketball and found the format a way to compete. For the first tournament, 18 friends showed up and played for an $18 purse.

From the beginning, the McNeals were a good fit for business. Scott handled promotion, Mitch the business end. They knew they wanted the Macker to be a family event and open to players of all ability levels. That meant no alcohol. It also meant that all male or female players aged seven all the way up to 50 and over were eligible. Age, height, and experience are taken into account when assigning teams for the double elimination competition. There is a consolation bracket, the Toilet Bowl, for teams eliminated in their first two games. A GusBuster mans each court to maintain order.

The event grew to the point that in 1991, in Belding, there were 5,400 players and around 300,000 spectators. They took the show on the road in 1987, and in that first year, the Gus Macker All-World Tour attracted more than 10,000 players in the five participating cities. Scott McNeal has retired from teaching history and coaching to work full time on the Gus Macker, though he still announces games. It is estimated that in 2011, with more than 75 cities hosting tournaments, there were more than 200,000 players, with 1.7 million spectators.

Gus Macker tournaments have raised approximately $15 million for charities in the cities where they are held. They also provide a good value to sponsors, though to keep the tournaments the family-oriented wholesome events they have always been, the Macker does not allow alcohol or tobacco sponsors. Like any successful venture, there are three-on-three tournament imitators, but they have proved no threat to the first and the best.

The image below shows the tournament in Belding, Michigan, in 1991.

Martin Morales

Since coming to Grand Rapids in the late 1960s, Martin Morales has advocated for his people. Originally from Texas, he soon became a leader and businessman in the local Latino community and was able to buy the popular Little Mexico restaurant for $4,500. His true love is local politics, and though he ran for mayor and lost, he probably accomplished more by flamboyant activism. When he thought the school board wasn't doing enough for Hispanic children, he tried conventional methods of getting their attention. When that failed he rode a horse into city hall, and got just inside the entrance before security made him leave. Now retired, Martin still follows local happenings, and is still called upon for advice. He is shown here in his apartment, standing beside a portrait of himself. (Photograph by Jay de Vries.)

CHAPTER FIVE

1981–Present

These were years of unprecedented technological advances along with renewal and growth in downtown Grand Rapids. Ronald Reagan, George H.W. Bush, Bill Clinton, and George W. Bush had their turns in the White House, and in 2008 Barack Obama moved in. Michigan elected governors Blanchard, Engler, Granholm, and Snyder.

Yuppies replaced hippies. Rob Bell established Mars Hill Bible Church. Chris Kaman played for the Los Angeles Clippers. Jeff and Karen Lubbers chose farming over running a business.

A Wyoming veterinarian gave cats a place to stay while waiting for their forever homes, and pool league team members made it a point to take care of their own. Bich Nguyen told us what being an Asian immigrant felt like, and Gary Schmidt introduced us to *Lizzie Bright*.

But some things remained the same. The Jackie Middleton Trio still played dance music, Tommy Brann still served the Southwest Michigan favorite tri-tip sizzlers, and Gus Macker tournaments were still proving that basketball was more fun as a game than as big business. Dick Ter Maat's Otherway Ministries still worked at turning West Side renters into homemakers.

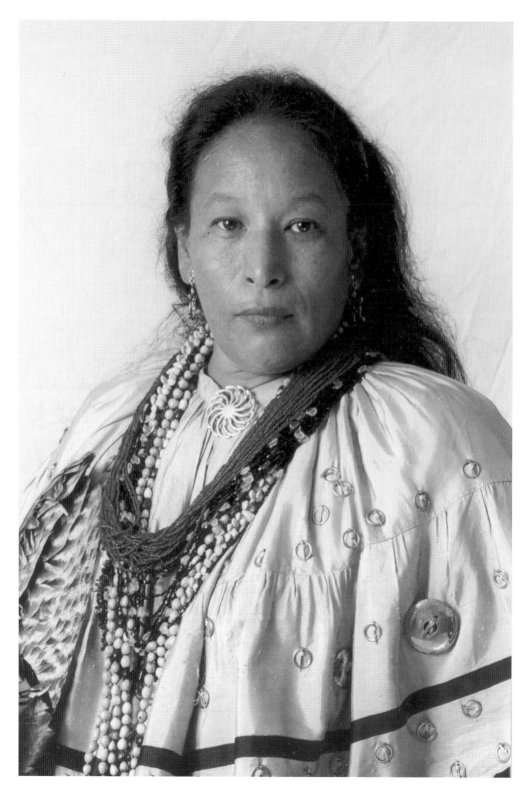

Debra Muller (LEFT)
A tireless advocate for Michigan's indigenous people, Muller managed the Norton Mounds Project, undertaken by the Public Museum to protect and maintain 13 Native burial sites located in Millenium Park. She taught young Natives to be proud of their heritage through dance, theater, and art, and *Grand Rapids Business Journal* named her one of the Fifty Most Influential Women of West Michigan.

Jackie Middleton
Jackie Middleton began performing with her musician parents at Camp Lake, near Sparta. It was 1950. She was 12 years old and is still going strong. Though best known as an accordion player in the Jackie Middleton Trio, she also plays clarinet and played that instrument in what started out as the Middleton Brass Band. The group practiced at the Middleton Music Company and neighbors brought lawn chairs out to sit and listen. Later called the Calder City Band, it grew to about 30 members. Middleton Trio members changed occasionally over the years, but the toe-tapping dance music at various clubs, weddings, and other events was a constant. Pictured with Middleton are Sparky Harris on drums, and Ed Barr playing the saxophone. (Courtesy of Jackie Middleton.)

Chris Kaman (LEFT)

National Basketball Association forward Chris Kaman, number 35, began his basketball career at Tri-Unity Christian High School in the suburb of Wyoming. After high school graduation, he attended Central Michigan University in Mount Pleasant where he played for three seasons after which he made the decision to go professional, and was then drafted by the Los Angeles Clippers NBA franchise. In 2012, midway through the season, he was traded to the New Orleans Hornets. Because of Kaman's German heritage, he applied for, and received, dual citizenship. This enabled him to join Germany's Olympic basketball team in Beijing in 2008. He made the team by scoring a double-double (10 points and 10 rebounds) in the pre-Olympic qualifying tournament. (Courtesy of the NBA.)

Jeff and Karen Lubbers

The Lubbers were operating a business in 1986 when their six-year-old daughter Jamie was diagnosed with cancer. They realized there was little they could do. The one thing Karen could control was what Jamie ate. Thus began a chemical-free diet that included raw milk. While they can't claim it cured her, Jamie, shown with Jeff and Karen above, has been cancer-free for 20 years. In 1995, they sold their company and began the sustainable Lubbers Family Farm. Far more than a farm, it includes the Cowslip Creamery selling raw milk aged cheese, and Little Rooster Bread Company specializing in fermented breads and other products. During the summer they host numerous events, including the Farm to Table series where they partner with local restaurants to serve gourmet meals al fresco. As the name implies, all the food comes from the farm and is chemical free. (Courtesy of Karen Lubbers.)

Rob Bell

Robert Holmes Rob Bell Jr. is the author of *Love Wins,* the controversial bestseller that brought him national acclaim. *Time* magazine called him one of 2011's 100 most influential people in the world. Bell founded the Mars Hill Bible Church in 1999 and in late 2011, decided it was time to move, and announced his decision to move to California. (Courtesy of Mars Hill Bible Church.)

Bich Minh Nguyen

Vietnamese-born Bich Minh Nguyen immigrated to Grand Rapids with her father, sister, grandmother, and uncles in 1975 when she was a year old. Saigon had fallen to the Vietcong, and the family sought a better life in East Grand Rapids. Her introverted personality made her a stellar student, and provided the introspection required of a writer, particularly in the memoir genre. Nguyen explored her immigrant experience in *Stealing Buddha's Breakfast* and *Short Girls.* In addition to her writing, she teaches at Purdue University. (Courtesy of St. Martin's Press.)

Tommy Brann
The name Brann has long been synonymous with restaurants in the Grand Rapids area, and Tommy Brann has operated the one on Division Avenue in Wyoming for more than 40 years. He has always been more than a business owner, and takes an active role in keeping the neighborhood stable. When he realized people in the community were suffering economic setbacks, he decided to do something about it. He targeted those who struggled to make ends meet, and had no money left over for extras like restaurant dinners, and borrowed McDonald's You deserve a break today slogan. His ad in the *Advance* weekly newspaper invited readers to nominate families who deserve a break and treated them to free dinners (including tip!) in his restaurant. He describes himself as wearing an apron and ready to serve. Brann serves in more ways than one. (Photograph by Jay de Vries.)

Richard H. Harms, PhD
Without people like Richard Harms, the area's rich history would be lost. Before becoming curator of archives at Calvin College, he managed the Local History Department of the Grand Rapids Public Library. In addition, Harms is editor of *Origins*, the Calvin's Heritage Hall magazine focusing on the history of the Dutch in North America. The prolific writer has authored books on local history and is a frequent contributor to magazines including *Grand Rapids, Michigan History,* and *Grand River Valley History.* His magazine articles capture the essence of the always courageous, and sometimes outrageous, people who made Grand Rapids great. (Courtesy of Calvin College, Heritage Hall.)

Gary Schmidt

Calvin College English professor Gary Schmidt is also a critically acclaimed writer, having received two of the coveted Newberry Honor Awards in juvenile fiction for *Lizzie Bright and the Buckminster Boy* (2005) and *Wednesday Wars* (2008). They are just two of the more than 30 books he has authored for young readers. Schmidt, a New England native, has been teaching in Grand Rapids since 1985. When not teaching or writing, Schmidt can be found at his farm in the country, doing what he enjoys most: spending time with his wife and six children. Other interests include Chaucer and New England history. The lymphatic cancer survivor keeps in shape by gardening and splitting wood. (Courtesy of Gary Schmidt.)

Vernon J. Ehlers

Ehlers, a former Calvin College physics professor, served as US congressman for the third district, which includes Grand Rapids. This was the post once held by former president Gerald R. Ford. Ehlers was re-elected every two years from 1993 until his retirement in January 2011. (Courtesy of Vern Ehlers.)

Terri Lynn Land

Land earned a degree in political science from Hope College, located in nearby Holland, Michigan. She put it to good use by serving seven years as Kent County clerk and register of deeds, then, running as a Republican, she went on to become Michigan secretary of state in 2002, and was re-elected in 2006. Michigan's term limits prohibited her from running again. (Courtesy of Dan Hibma.)

Dr. Jennifer Petrovich and Crash Purr-Do
When someone rescued an injured kitten and brought him to local veterinarian Dr. Jennifer Petrovich, she wasn't sure she could save him. He had been hit by a car and suffered internal injuries along with three broken legs and other fractures. He recovered with everything but his tail intact. Dr. Jen named him Crash Purr-Do as he purred even when he was unable to move. Crash motivated her to found Crash's Landing, a rescue shelter for cats that have been traumatized. Three years later, she opened Big Sid's Sanctuary for cats stricken with feline leukemia or feline HIV. Both are no-kill facilities and are funded by donations and fundraising events. Dr. Jen's dedication to these animals is inspirational, and the army of 200 unpaid volunteers who take care of the cats are also heroes. Crash's mascot duties include looking handsome for the cameras. (Courtesy of Dr. Jennifer Petrovich.)

Rhonda Ayers and Norman Wright

Rhonda Ayers and Norman Wright operate the American Pool Players Association's Midwest Michigan league. Both are avid players. They started the league in 1997 when Rhonda and her husband Pat's twins, Shelby and Shane, were babies and she wanted work she could do primarily at home. Norman and his wife, Kathy, have two grown children, Rachel and Derek.

By 2012, the initial 20 teams of seven players each had grown to 200. It is a league with heart. The annual Toys for Tots benefit tournament is shown above. One association member works in the court responsible for the children of parents whose parental rights have been revoked. She reported that because wards of the court age out of the system at 18, one of the judges has a large closet in her chambers in which she stocks basic housekeeping items for those young people starting their adult lives with no support system. Like Toys for Tots, the Judge's Closet Tournament required players and spectators to donate cleaning supplies, linens, small appliances, or other start-up household products. Each player was partnered with one of the teens, and in at least one case, the two are still in contact.

A player died unexpectedly of an aneurysm at age 40. The league staged a benefit and raised $5,000 for a headstone. On a smaller scale, when another player's mother was diagnosed with terminal cancer, he wanted to drive her from coast to coast so that she could see the sights she had thought she had plenty of time for. Because time was of the essence, a large event wasn't feasible. Ten teams assembled for a 50-50 tournament, and in a couple of hours raised enough money to at least buy a few tanks of gas, a real achievement at a time when prices were at an all-time high. Ayers insists that they don't do that much, that she just gets the word out and the players, described by her as the best people in the world, take over. Maybe, but it's clear the operators set a good example. From left are Rhonda Ayers, Patrick Ayers, and Norman Wright. (Photograph by Jay de Vries.)

Jeff Goodale

Jeff Goodale was a recipient of the pool league's compassion. For 10 years he had suffered from genetic polycystic kidney disease, two-and-a-half on dialysis. He knew firsthand the seriousness of PKD as his father and brother had both died of it. As it progressed, his energy evaporated, and he grew weaker. He went to work, and he slept. That was it. Goodale needed a kidney transplant, and while he waited for a donor, the league and his team responded in spades. They held two tournaments and three blood drives for his benefit. An unlikely donor surfaced: his boss. Immediately following the June 2011 surgery, he felt rejuvenated. Of one thing he is sure; being a member of a caring group makes bad times easier. A healthy Jeff Goodale is shown at a pool tournament with his wife Audrey and daughter Heather. (Photograph by Norma Lewis.)

INDEX